Lost in
London

A coloring tour
across England's capital

Sylvia Moritz & Rowan Ottesen

This book belongs to:

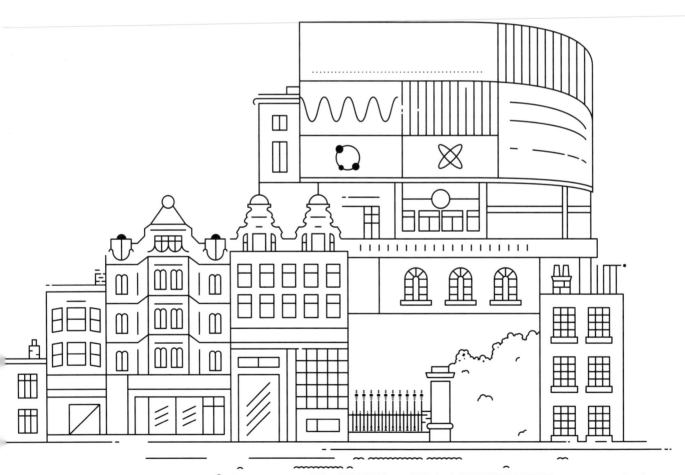

Lost in London

A coloring tour
across England's capital

Sylvia Moritz & Rowan Ottesen

hardie grant books

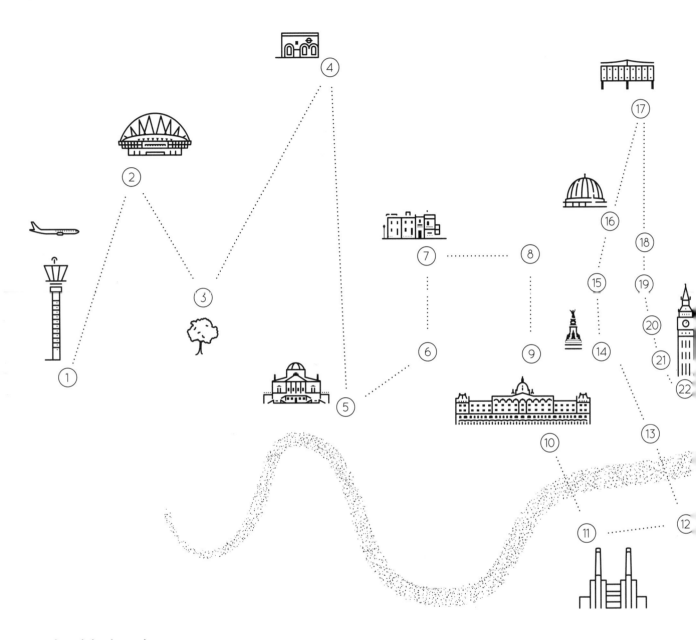

Lost in London
by Sylvia Moritz & Rowan Ottesen

Welcome to our coloring tour of the great city of London! Arriving at Heathrow Airport in the west, this book takes you across all of London's most famous and interesting places, departing at London City Airport in the east. Above is our zigzag map of all of the destinations that await you, each with its own spread for you to adorn with your chosen artistic tool. We hope you enjoy coloring in London, your way!

If you would like to see more of our work, you can find us on all social media @thecityworks.

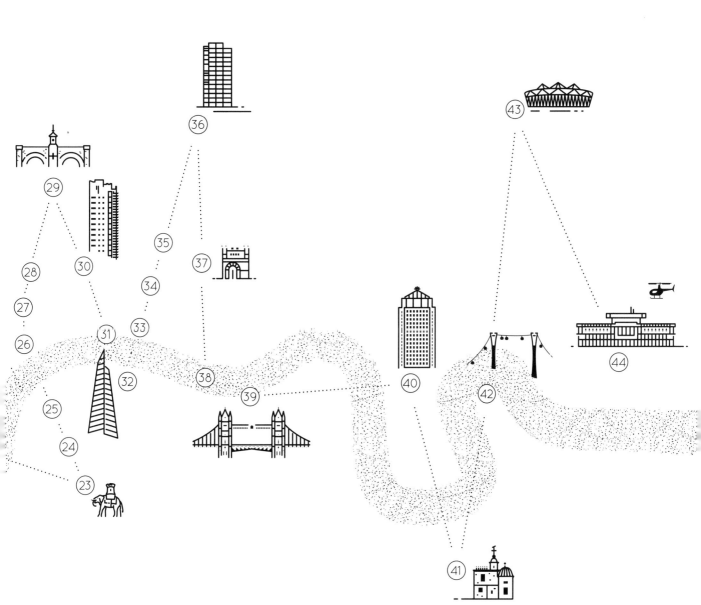

①	Heathrow Airport	⑫	Brixton	㉓	Elephant & Castle	
②	Wembley	⑬	Pimlico	㉔	Waterloo	
③	Kew Gardens	⑭	Buckingham Palace	㉕	Southbank	
④	Hampstead	⑮	Mayfair	㉖	Trafalgar Square	
⑤	Hammersmith & Olympia	⑯	Marylebone	㉗	Covent Garden	
⑥	Kensington	⑰	Camden & Primrose Hill	㉘	Holborn	
⑦	Notting Hill	⑱	Oxford Circus	㉙	King's Cross & Angel	
⑧	Paddington	⑲	Piccadilly Circus	㉚	Barbican	
⑨	Exhibition Road	⑳	St James's Park	㉛	St Paul's & Tate Modern	
⑩	Knightsbridge	㉑	Whitehall	㉜	London Bridge	
⑪	Battersea	㉒	Westminster	㉝	Monument & Bank	

㉞	Liverpool Street	
㉟	Shoreditch	
㊱	Hackney	
㊲	Brick Lane & Aldgate	
㊳	River Thames	
㊴	Tower Bridge	
㊵	Canary Wharf	
㊶	Greenwich	
㊷	Greenwich Peninsula	
㊸	Stratford	
㊹	London City Airport	

On average, an airplane takes off or lands from Heathrow Airport every 45 seconds.

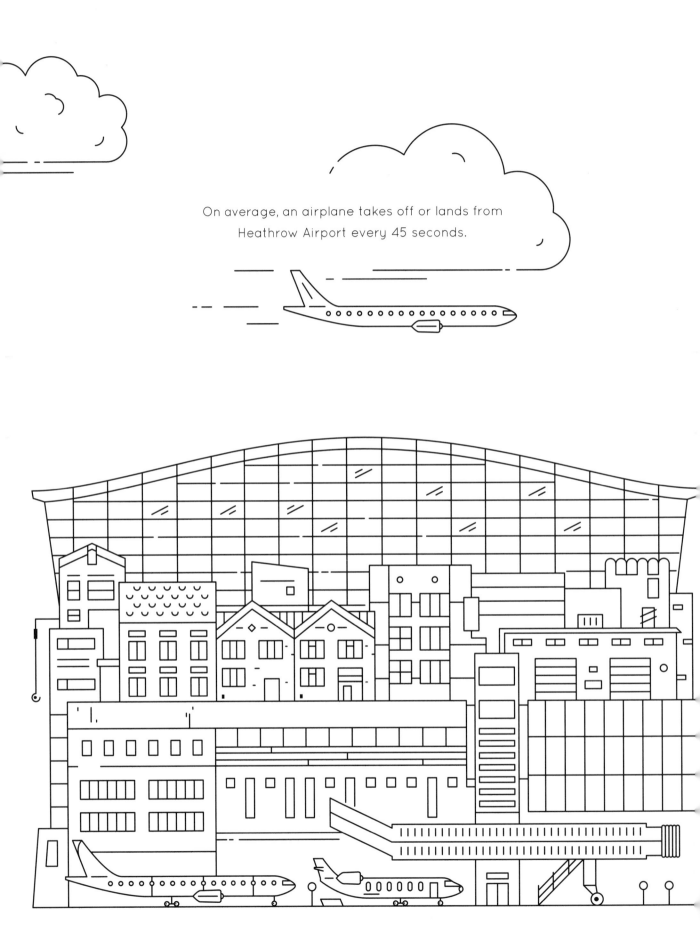

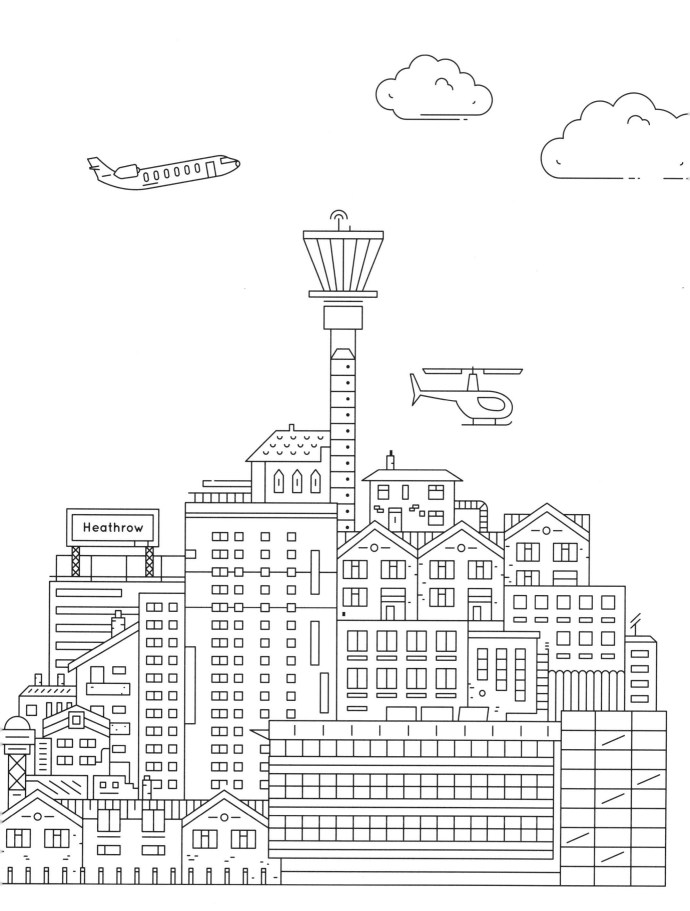

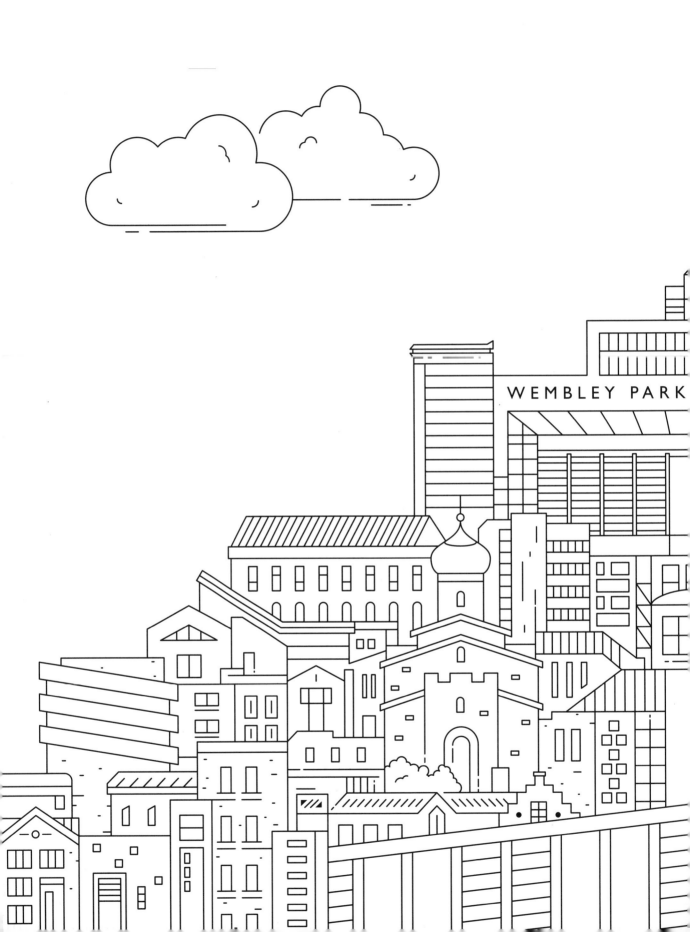

WEMBLEY PARK

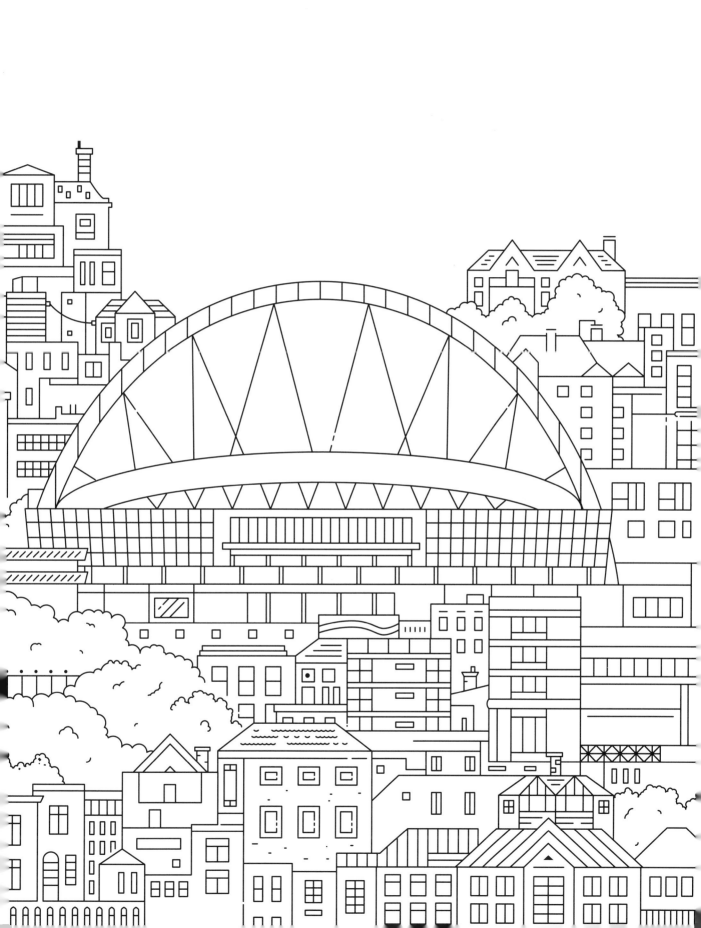

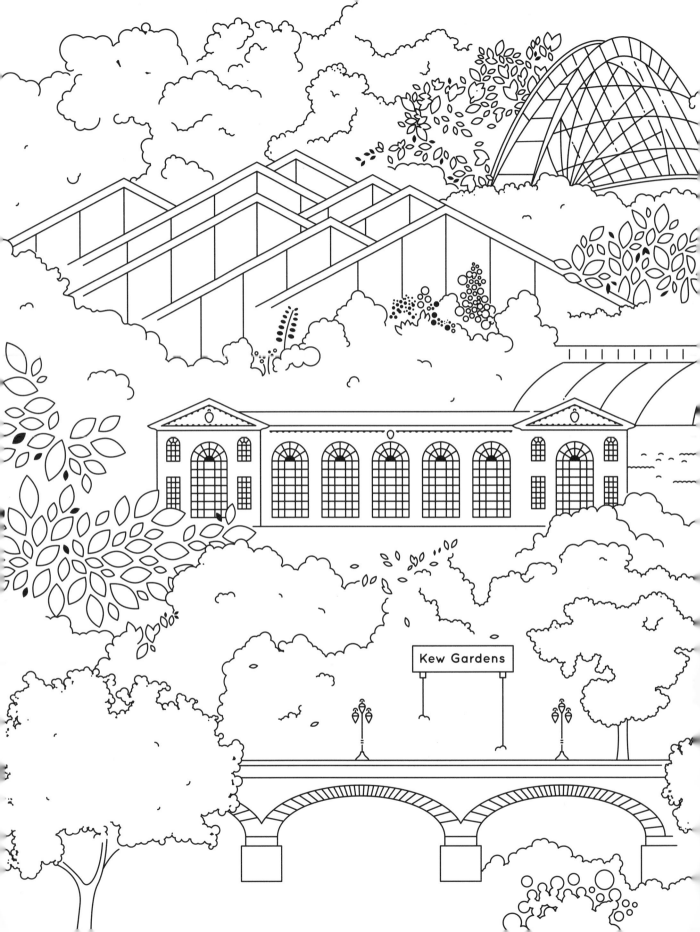

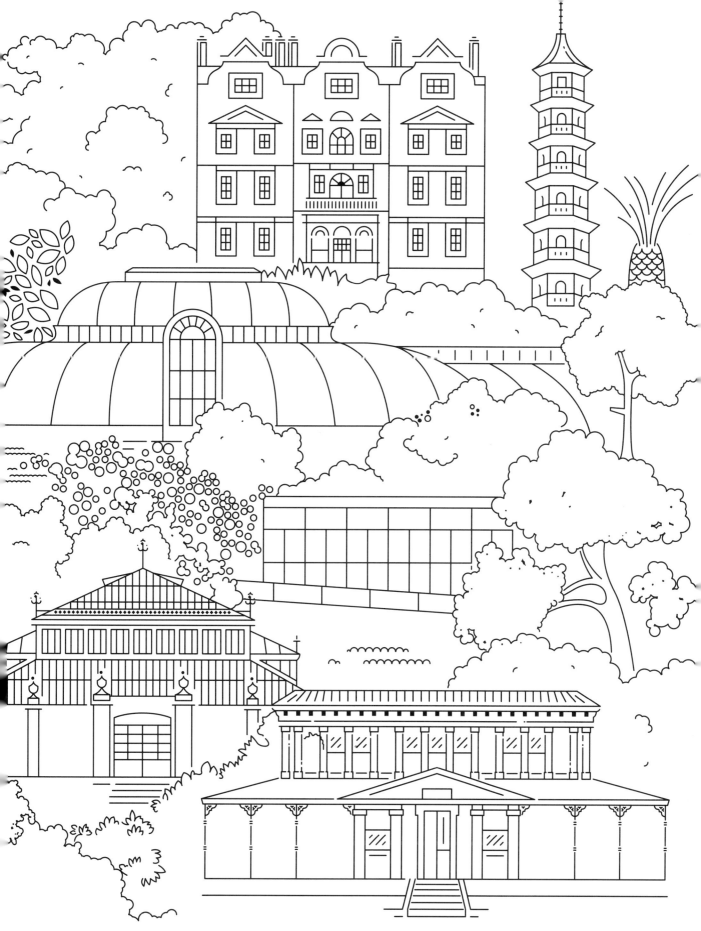

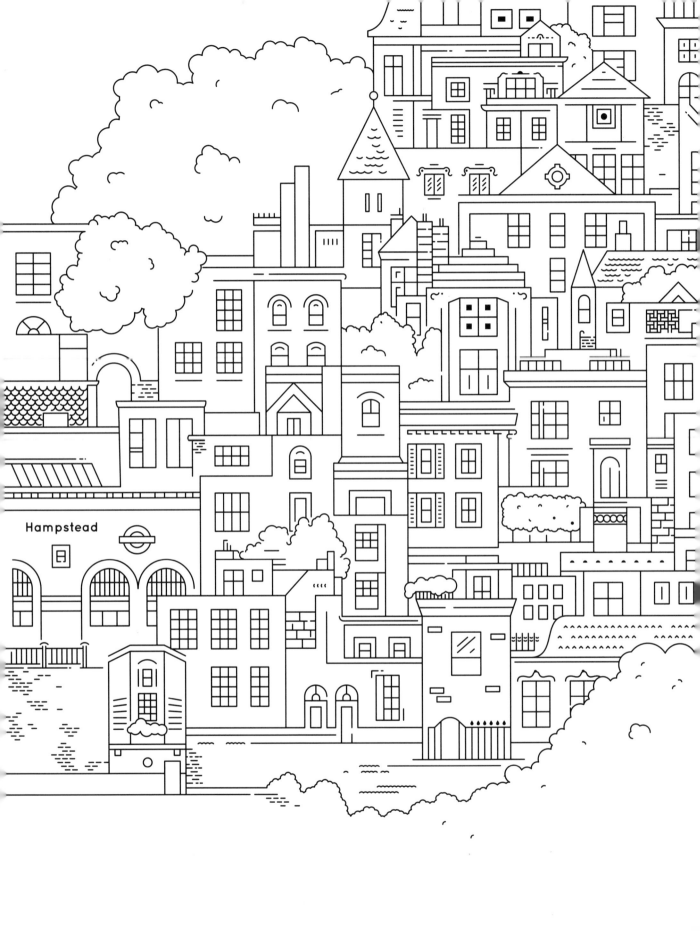

Hampstead

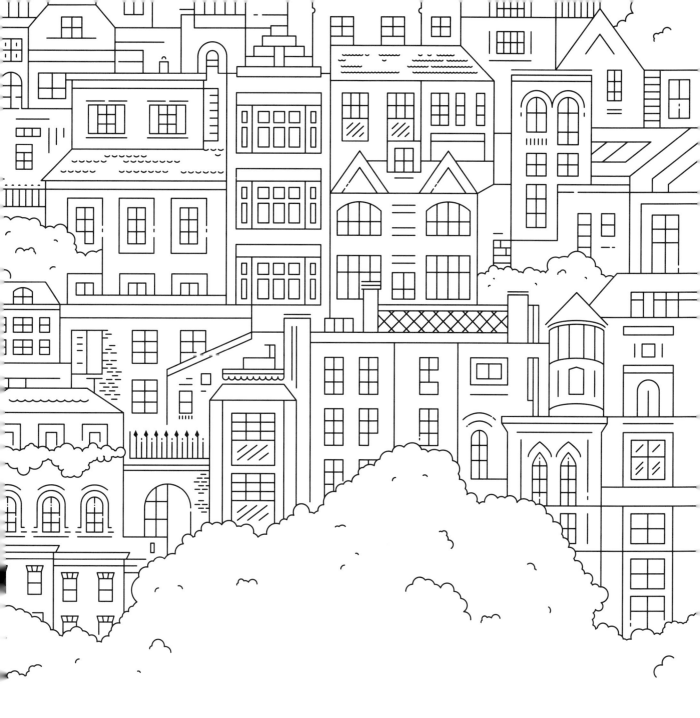

Hampstead has the deepest
underground Tube station in London.

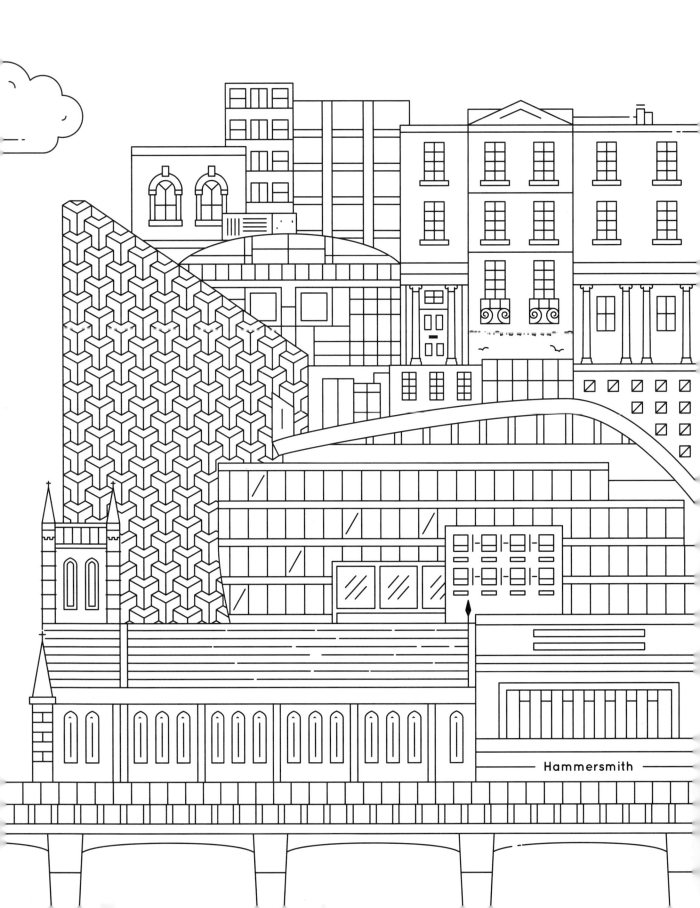

Hammersmith

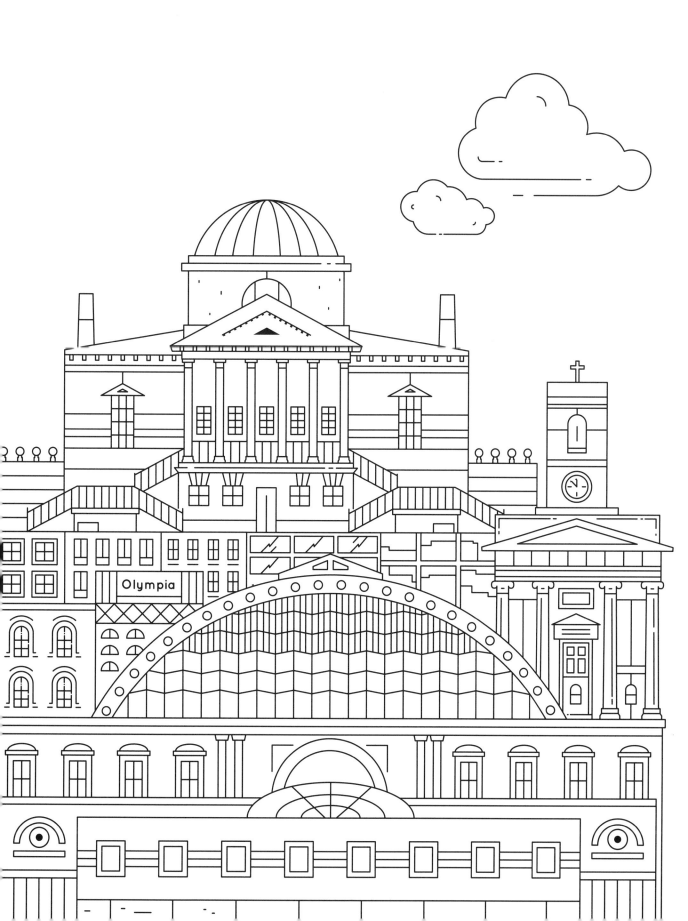

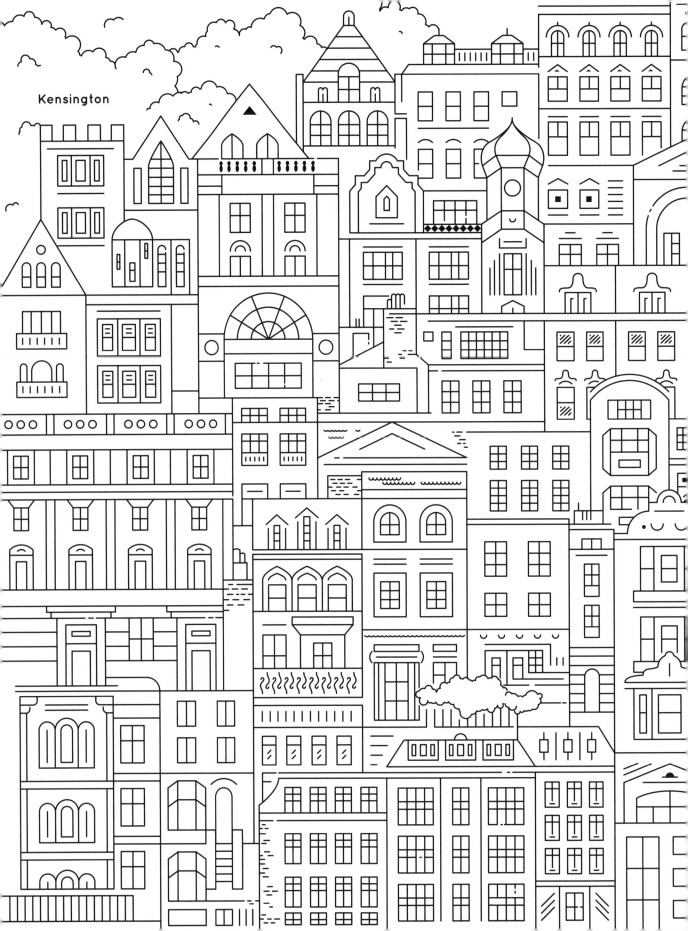

Kensington

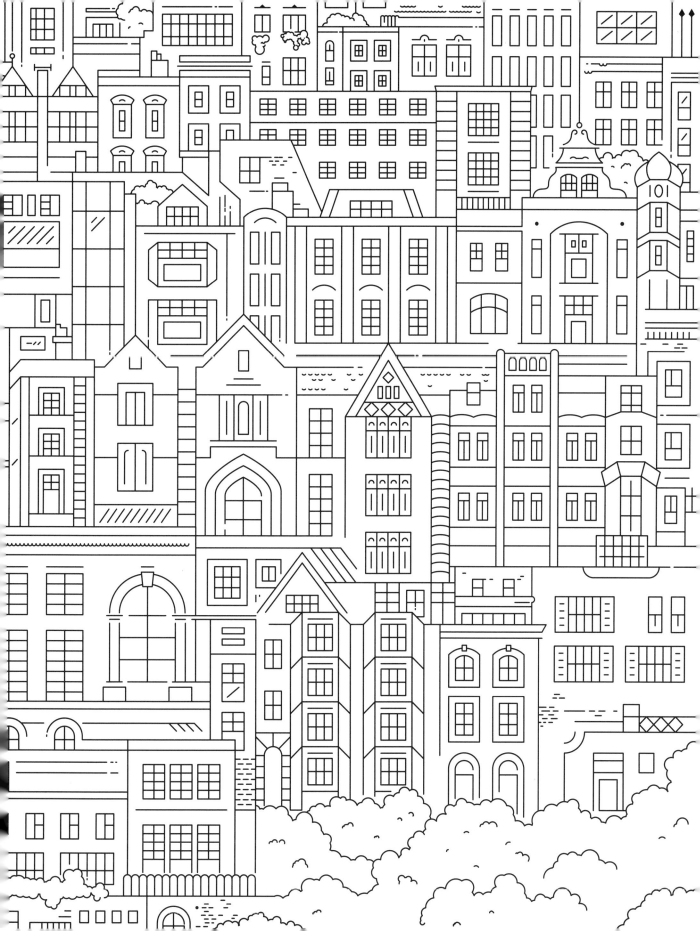

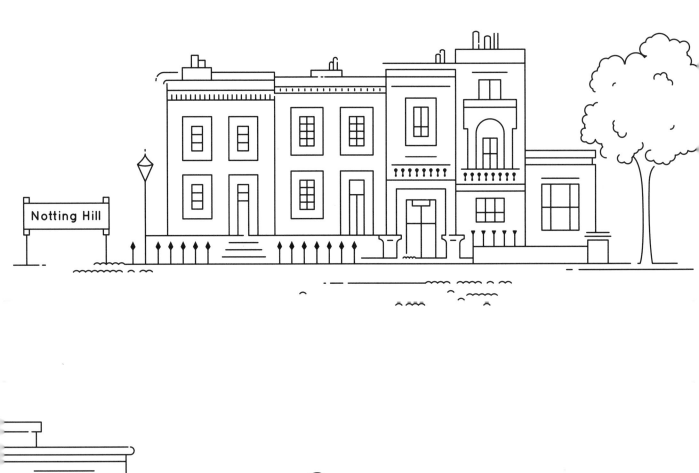

Notting Hill

Notting Hill Carnival attracts over 1 million visitors every year,
making it one of the world's largest carnivals.

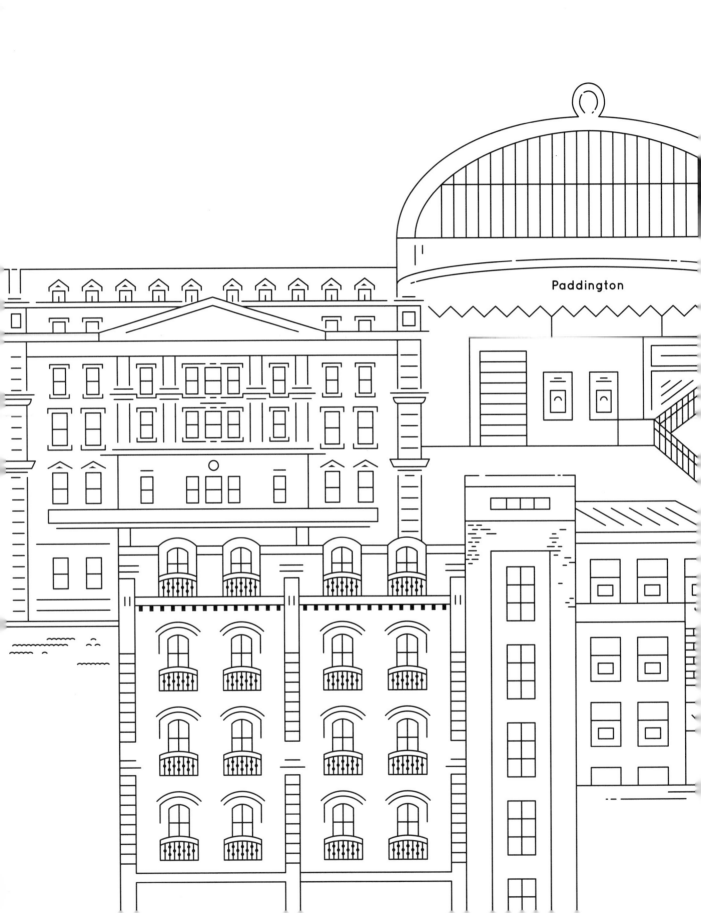

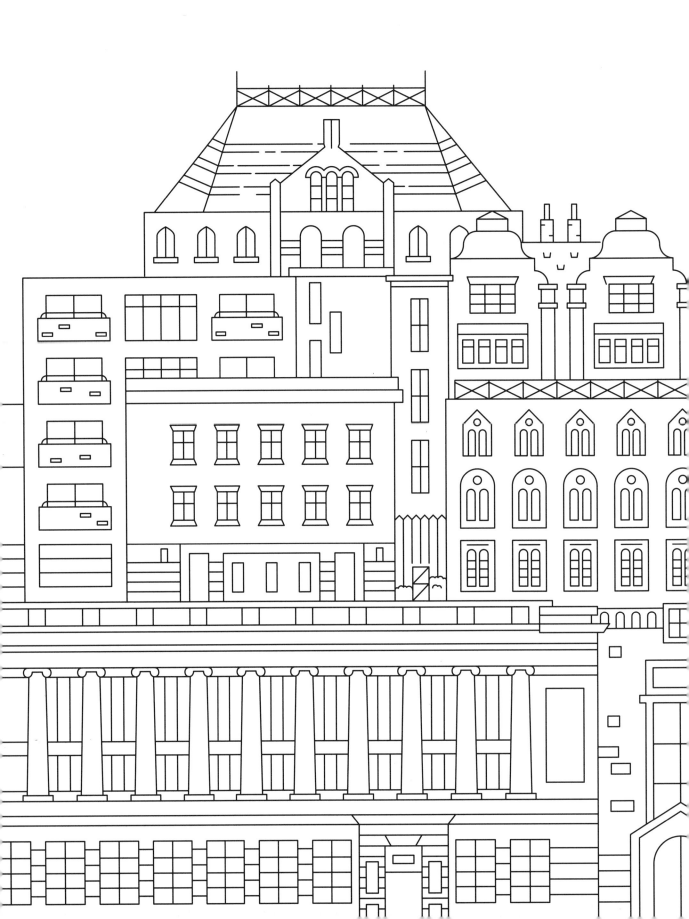

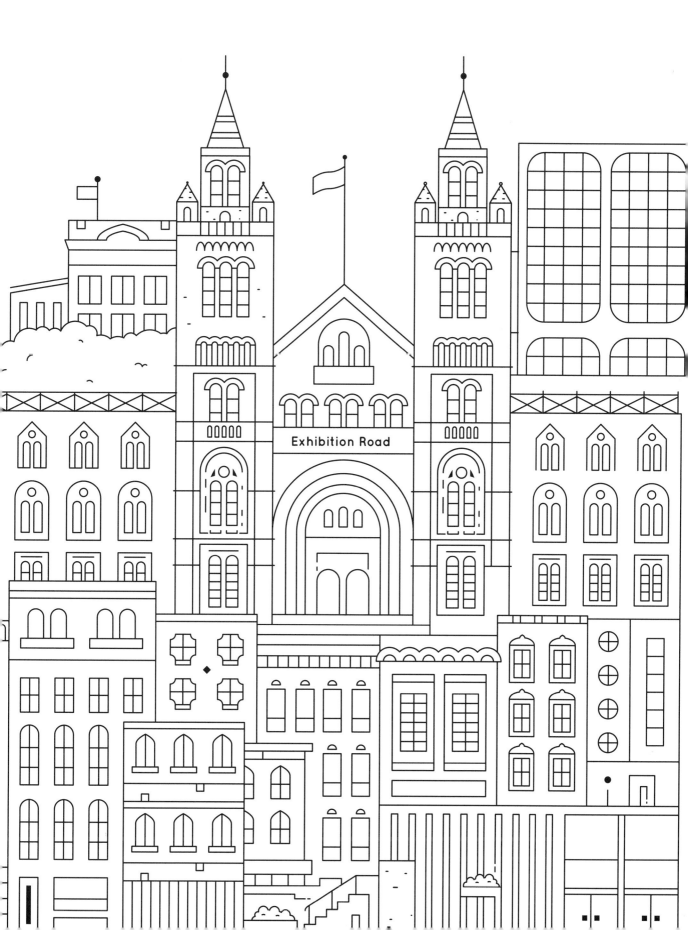

Exhibition Road

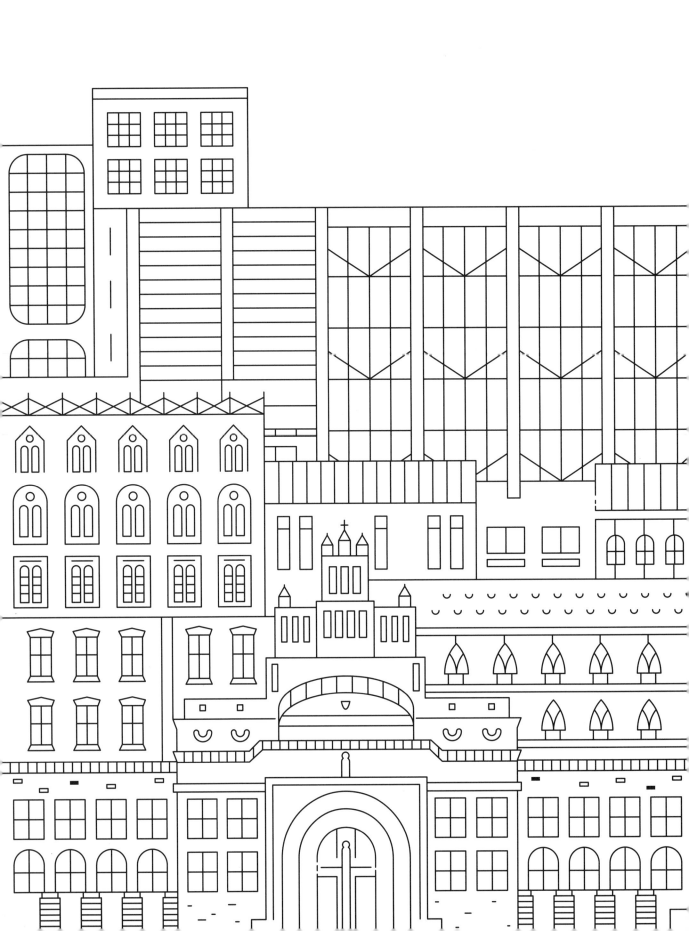

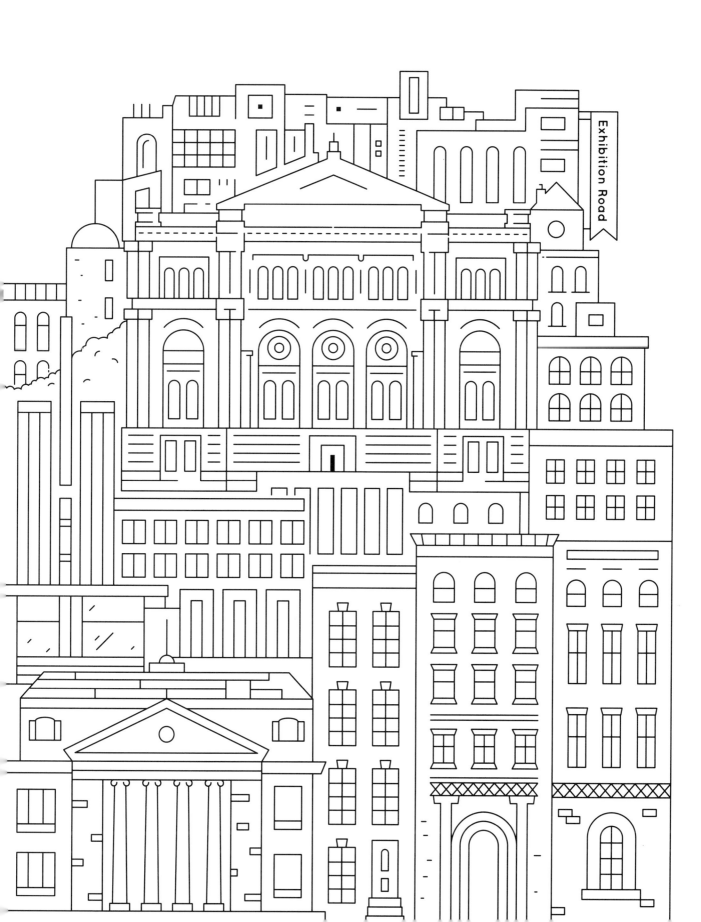

Exhibition Road

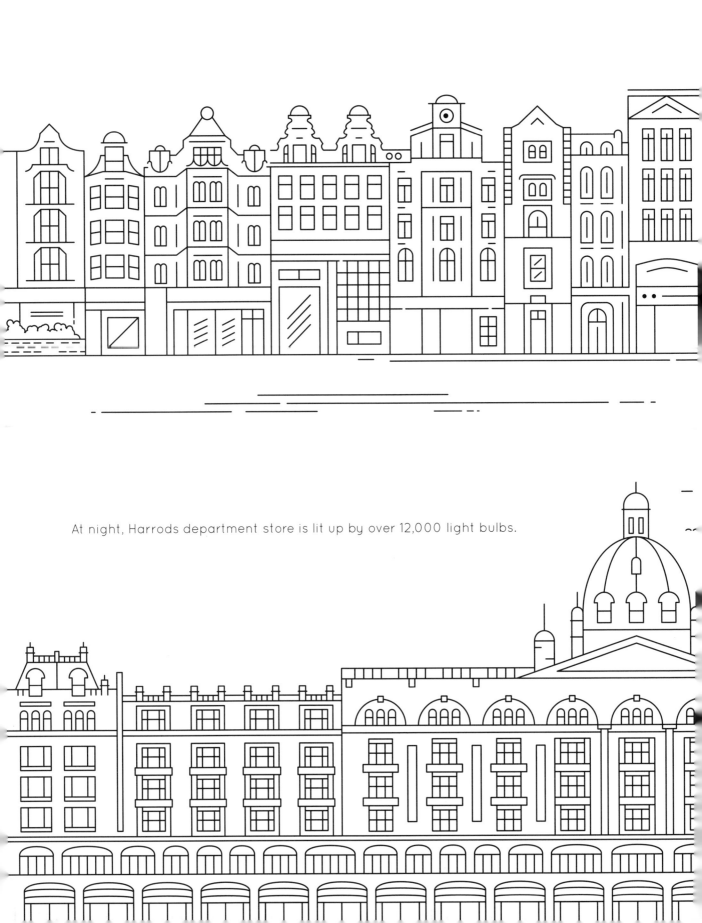

At night, Harrods department store is lit up by over 12,000 light bulbs.

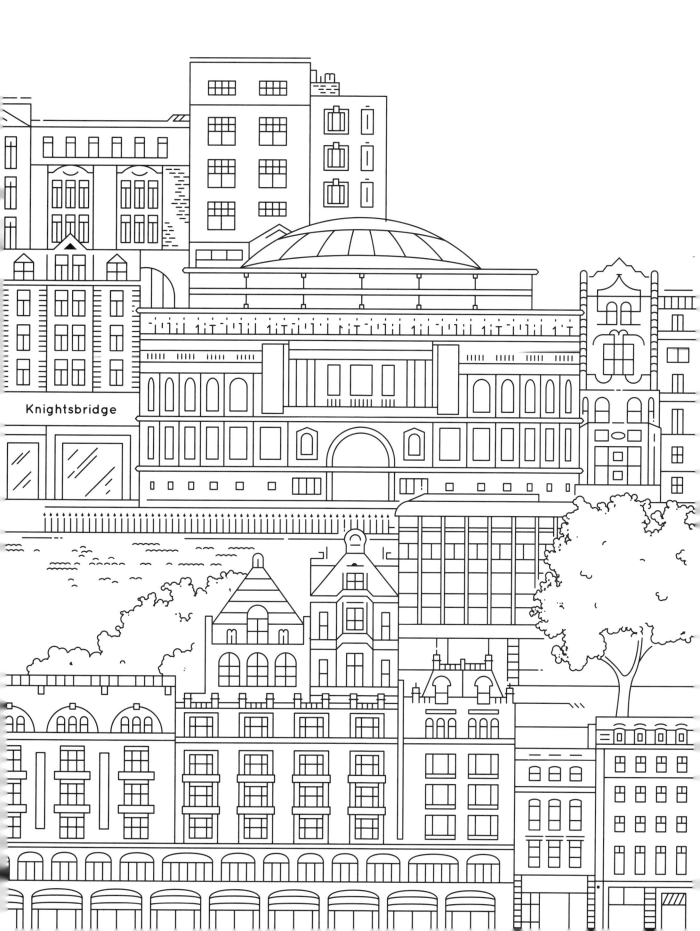

Knightsbridge

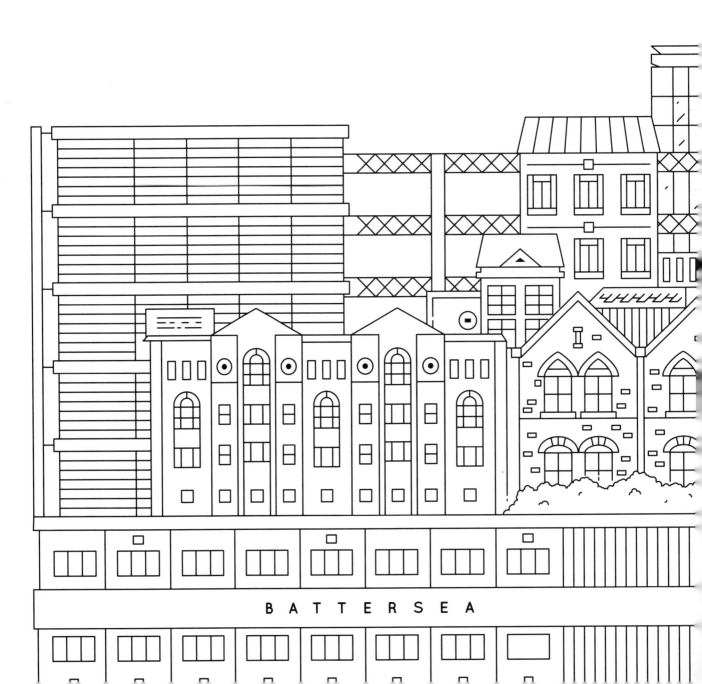

BATTERSEA

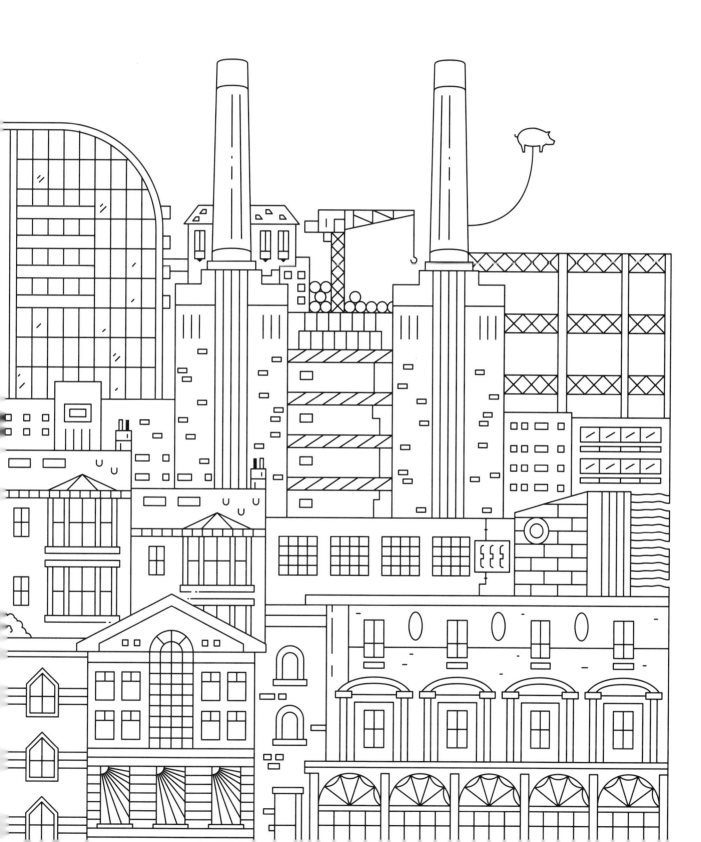

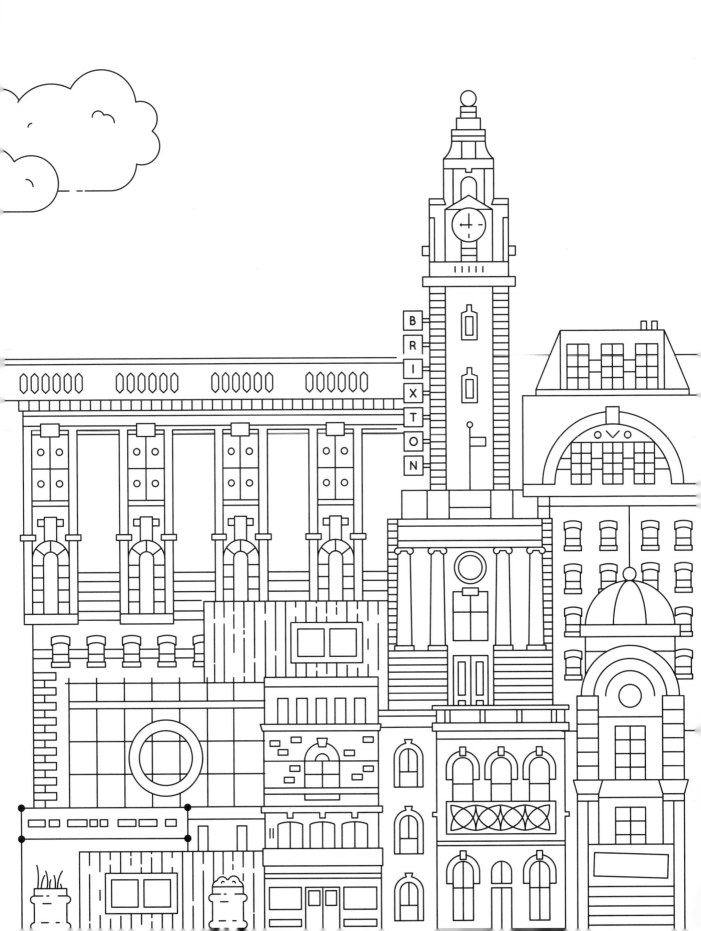

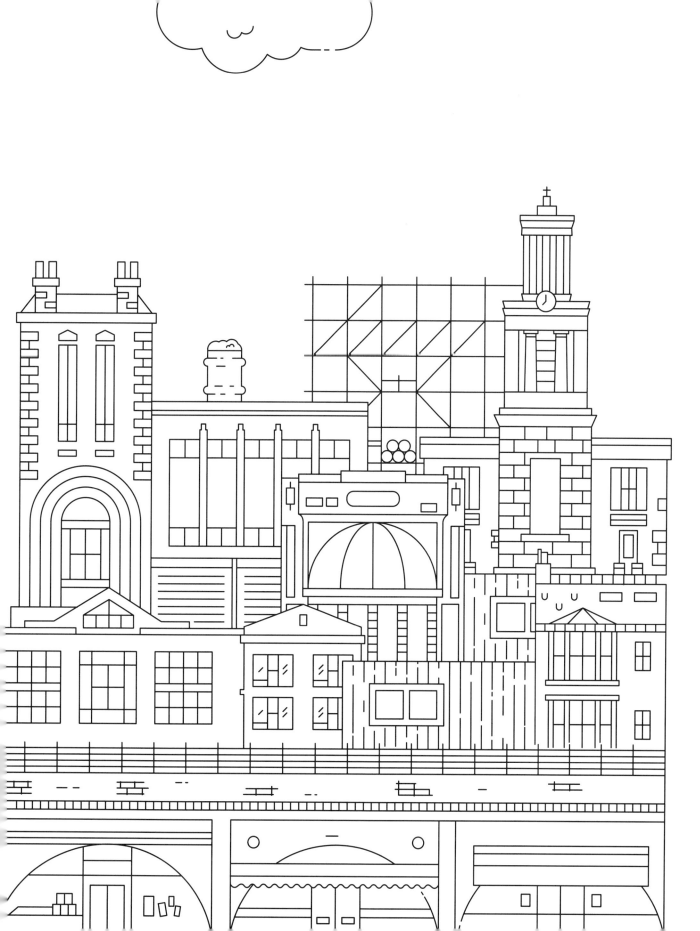

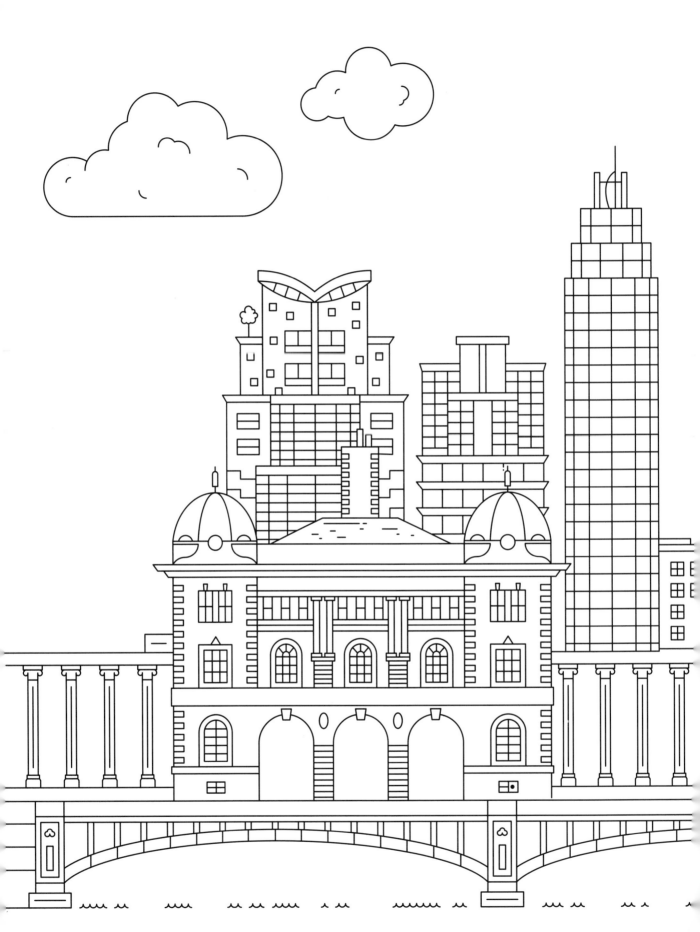

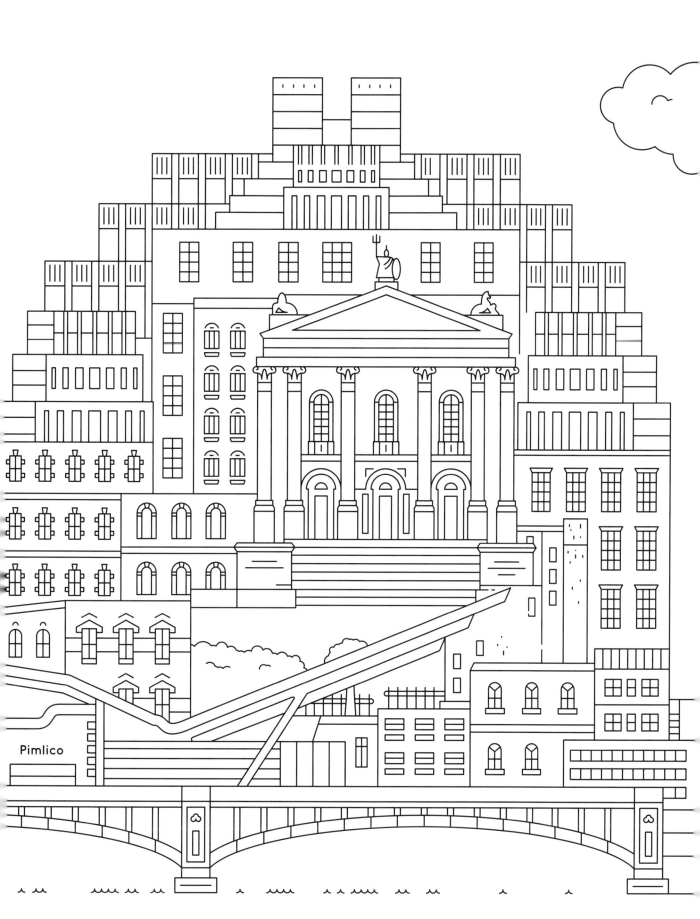

Pimlico

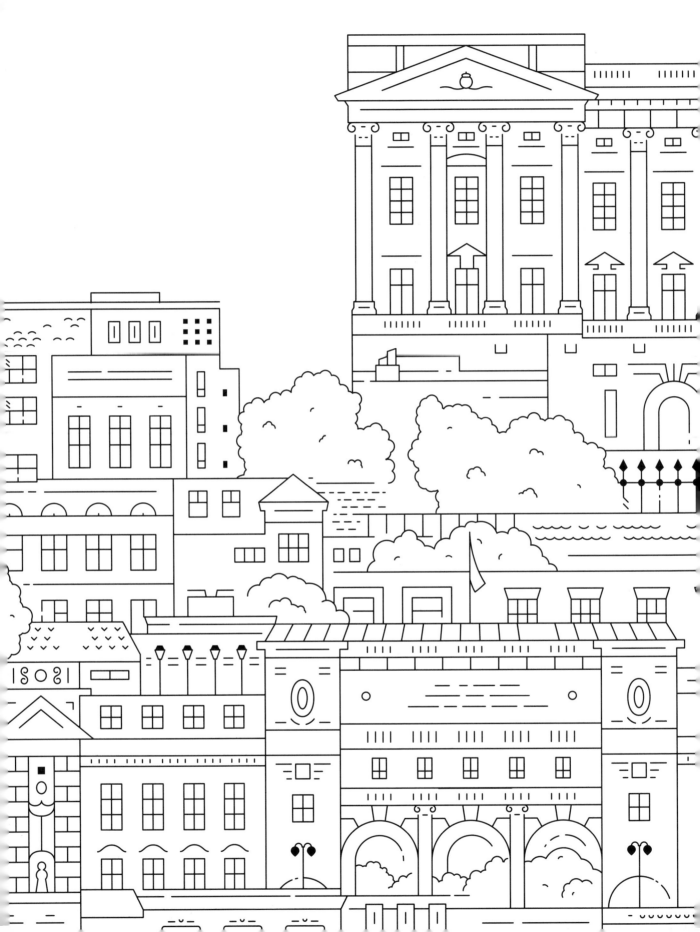

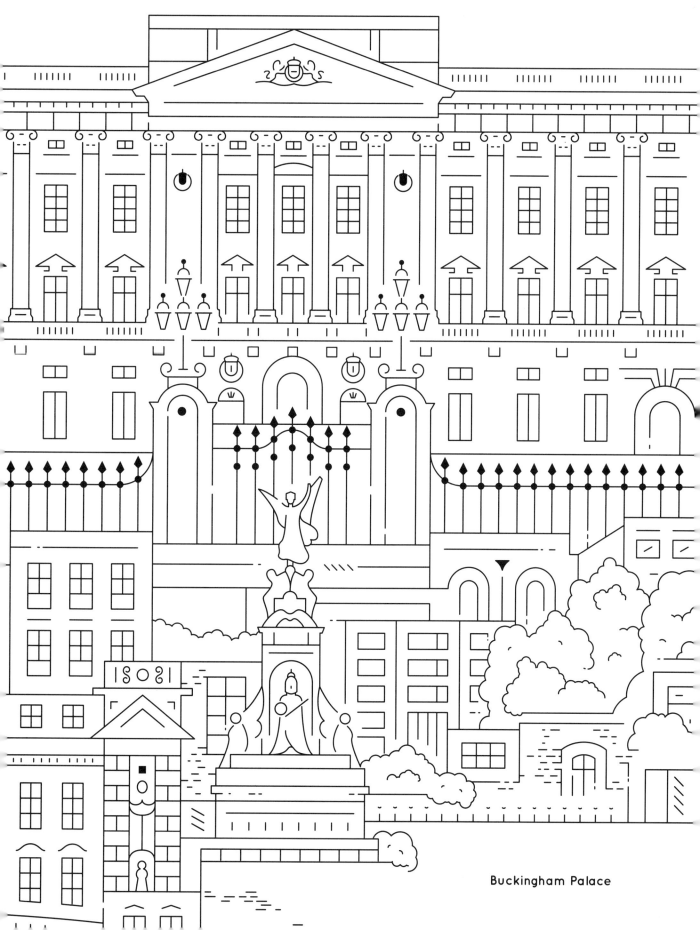

Buckingham Palace

Mayfair is named after a local fair
that used to take place every May
from 1686 to 1764.

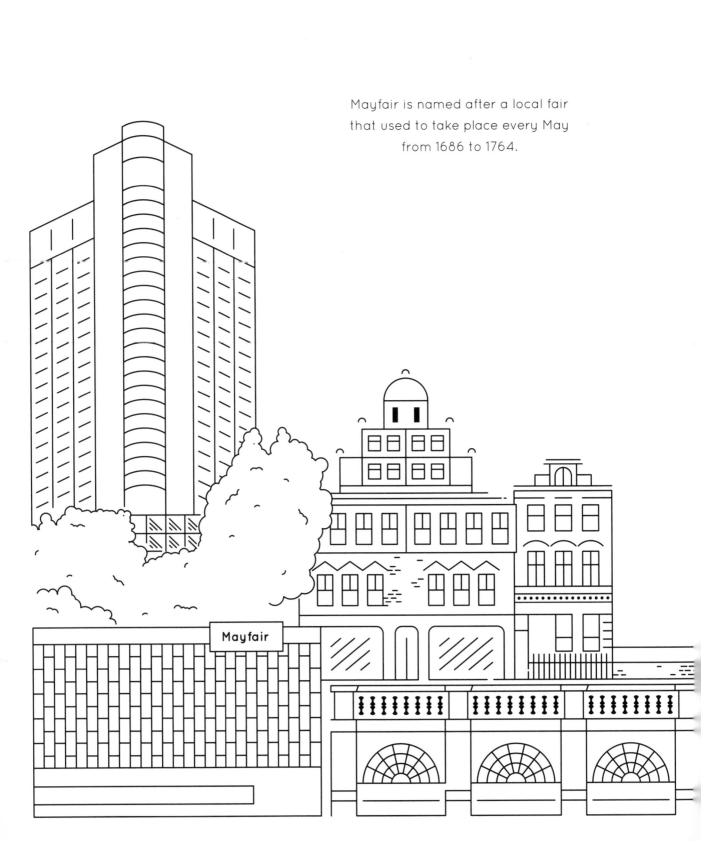

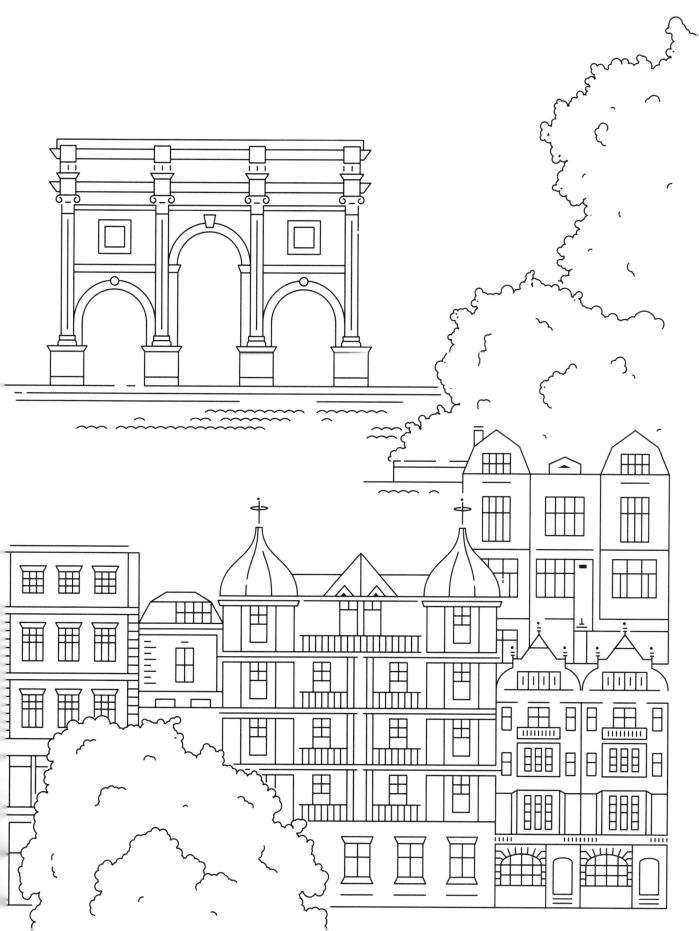

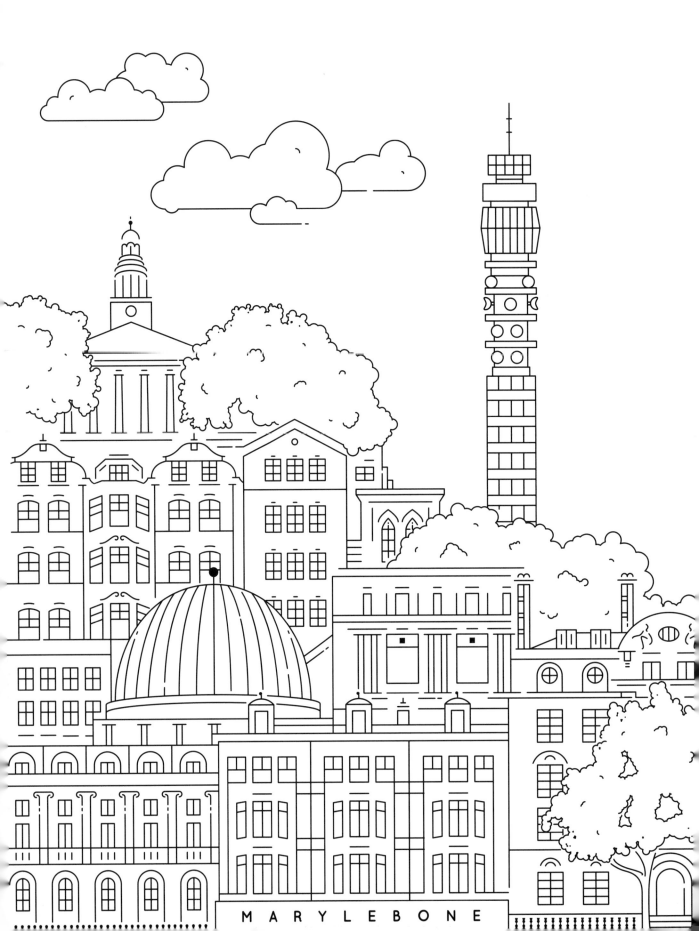

MARYLEBONE

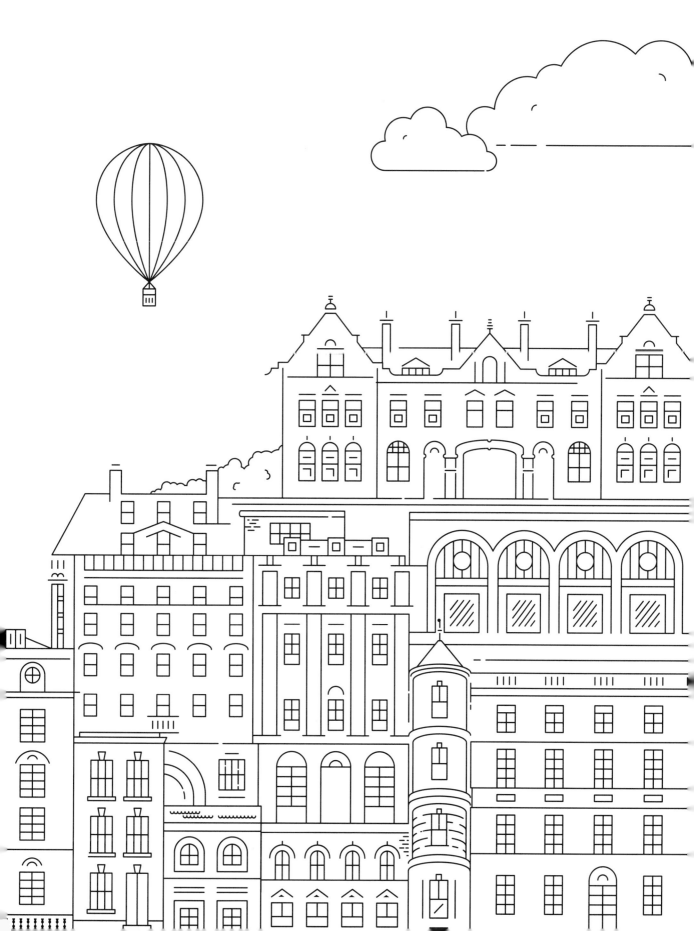

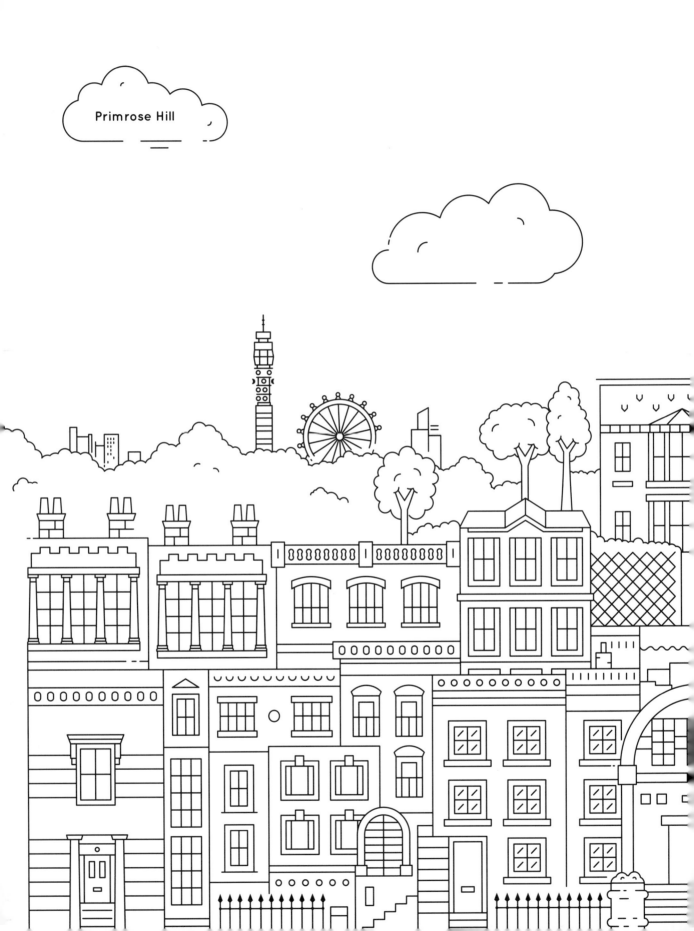

Primrose Hill

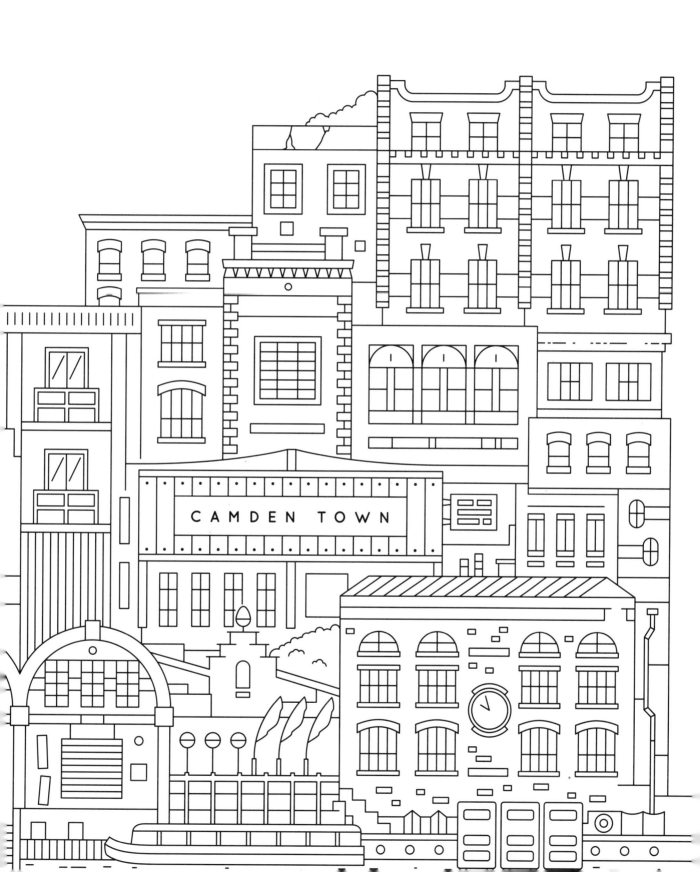

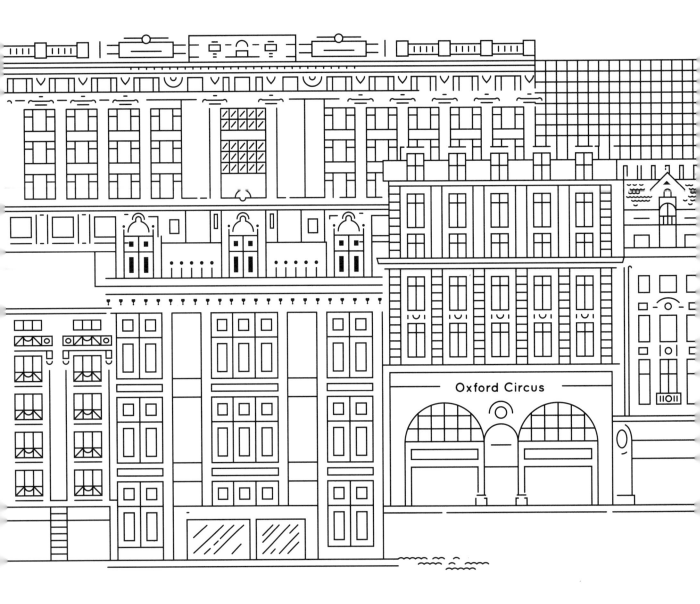

London's black cab drivers must learn 'The Knowledge' – a very
detailed test of London's roads, which takes years of study.

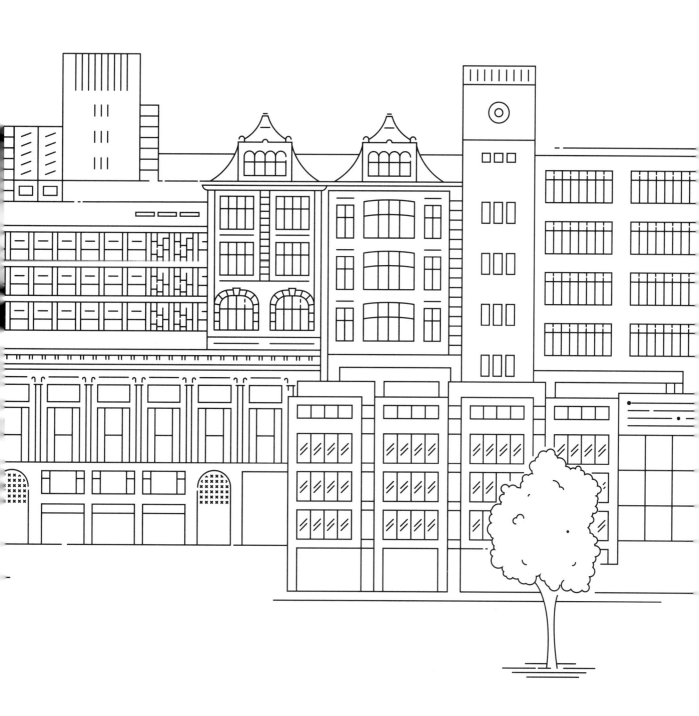

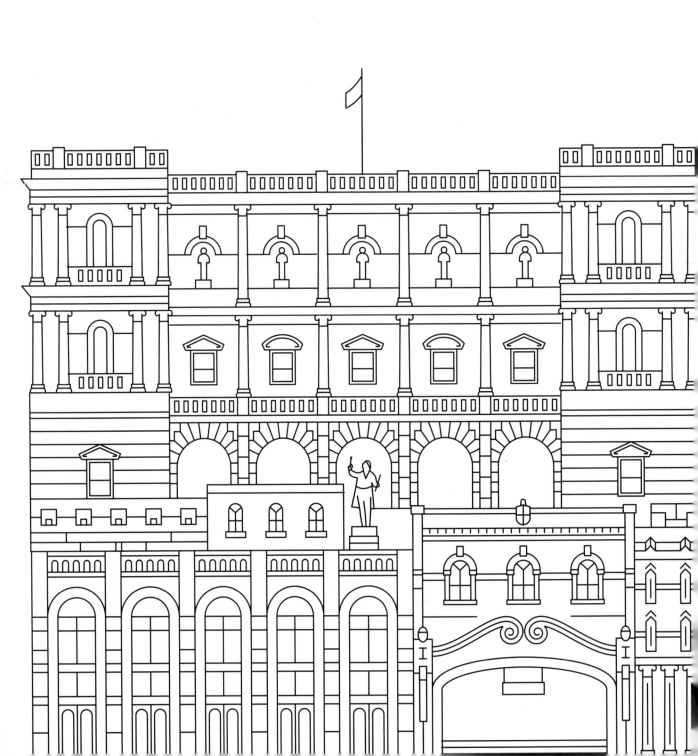

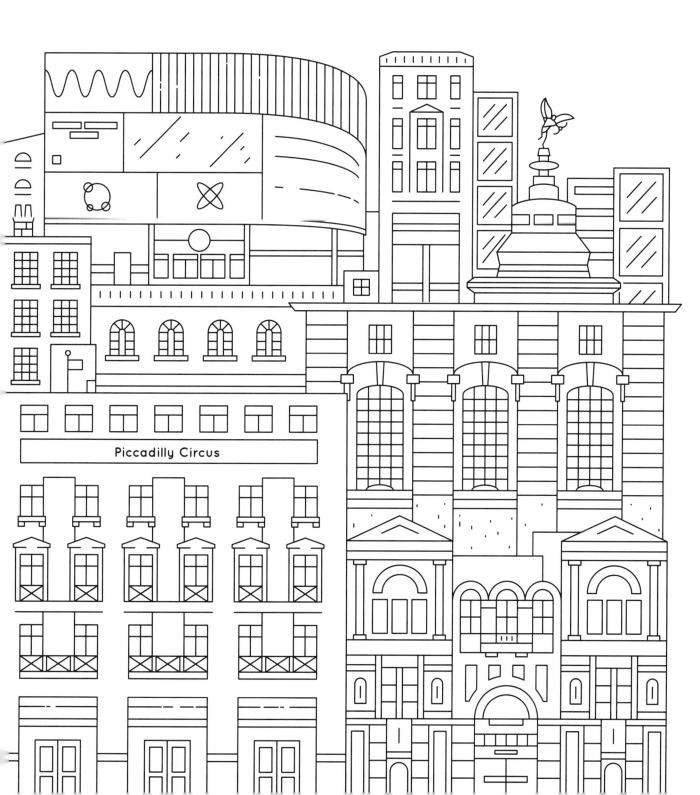

Piccadilly Circus

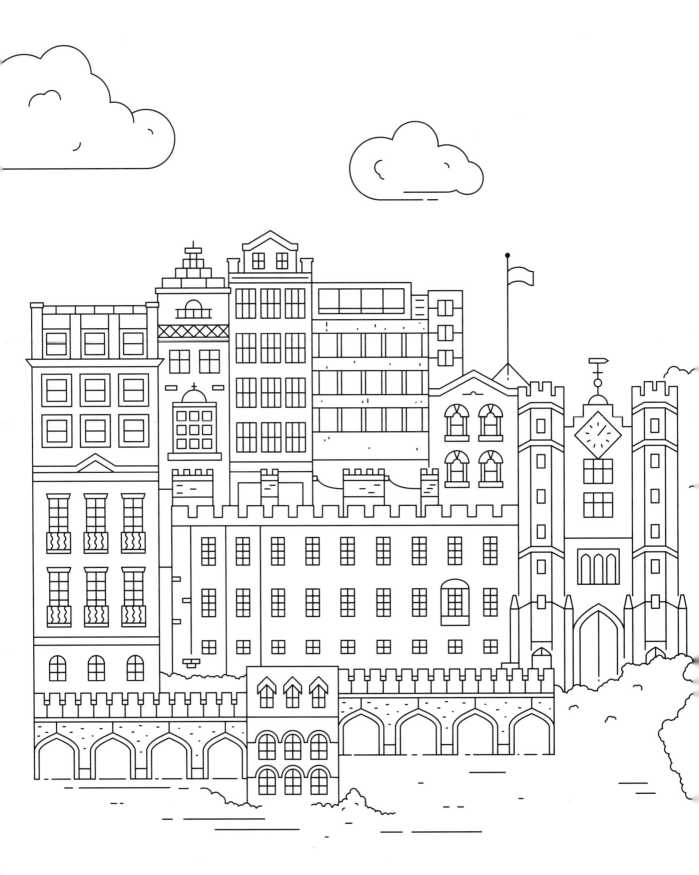

St James's Park _____

A group of pelicans has lived in St James's Park
ever since they were gifted from Russia in 1664.

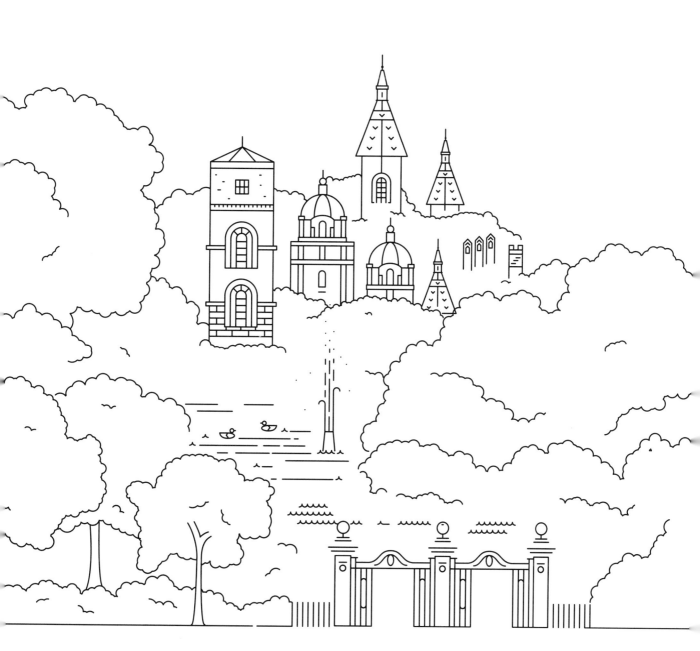

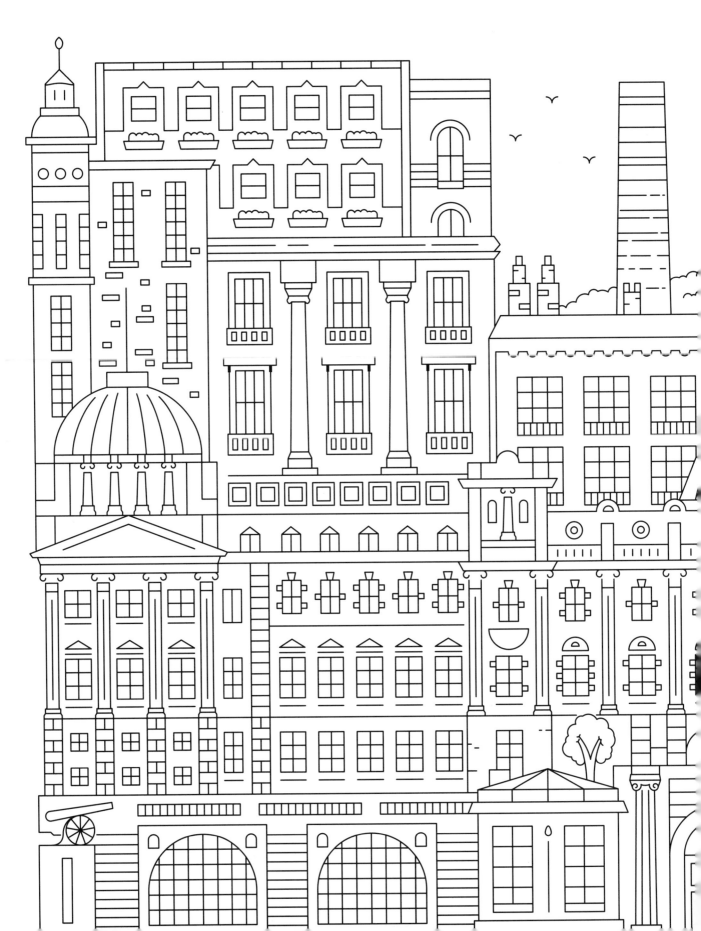

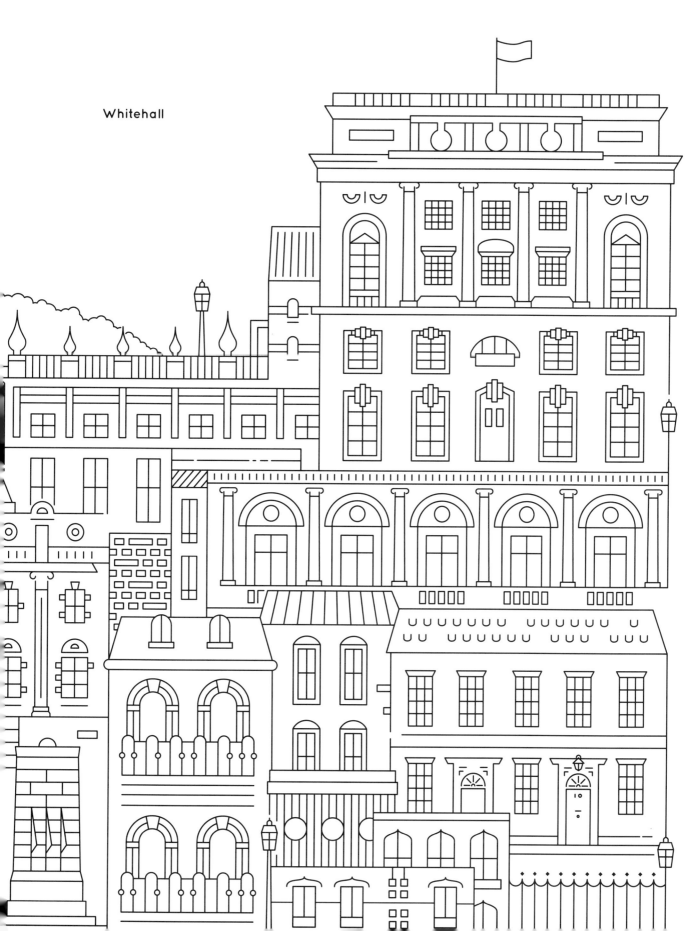

Whitehall

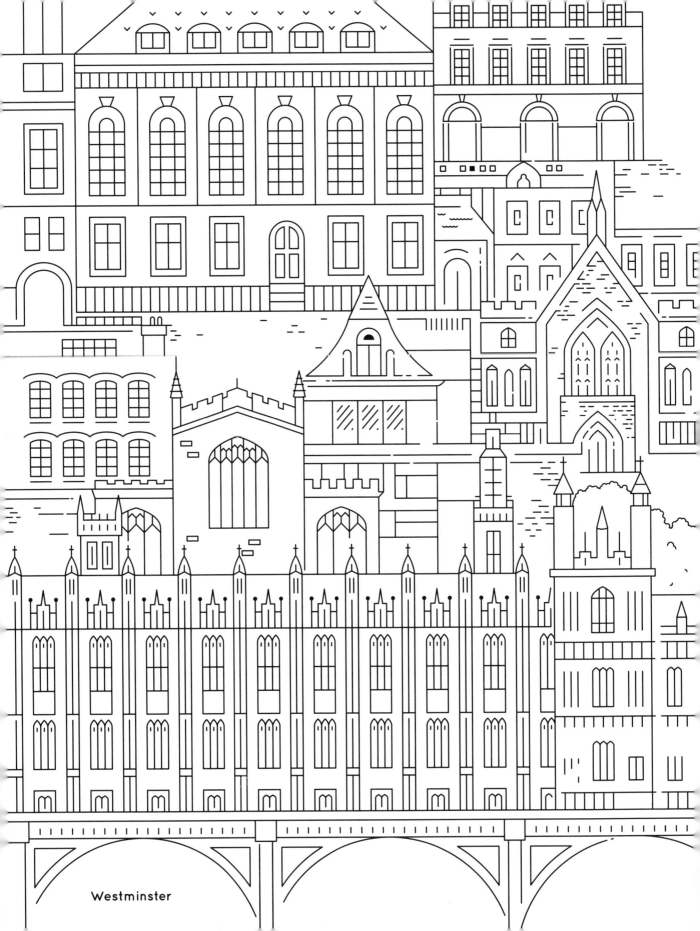

Westminster

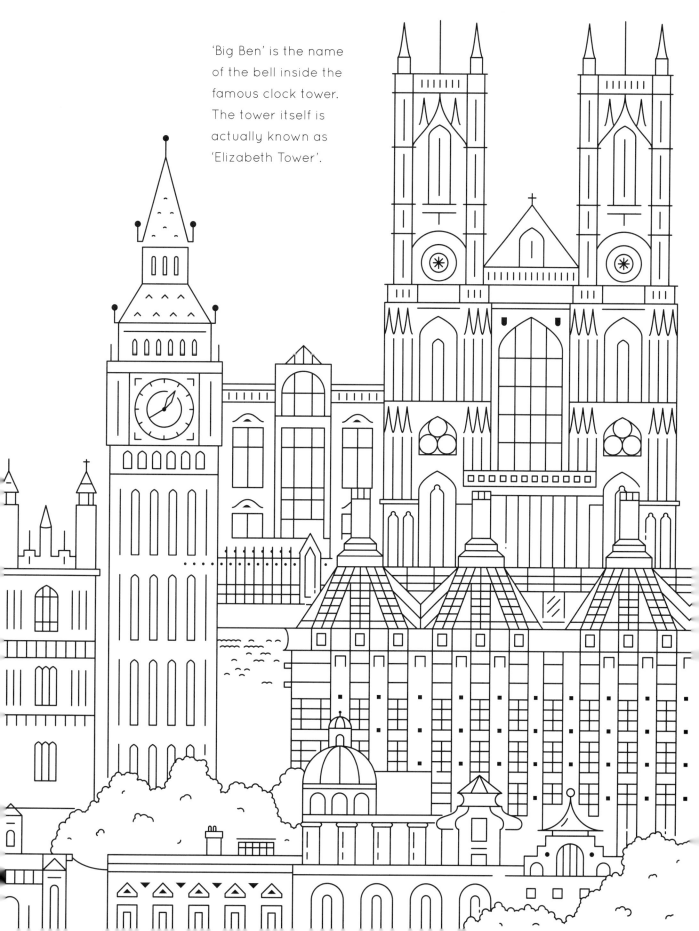

'Big Ben' is the name of the bell inside the famous clock tower. The tower itself is actually known as 'Elizabeth Tower'.

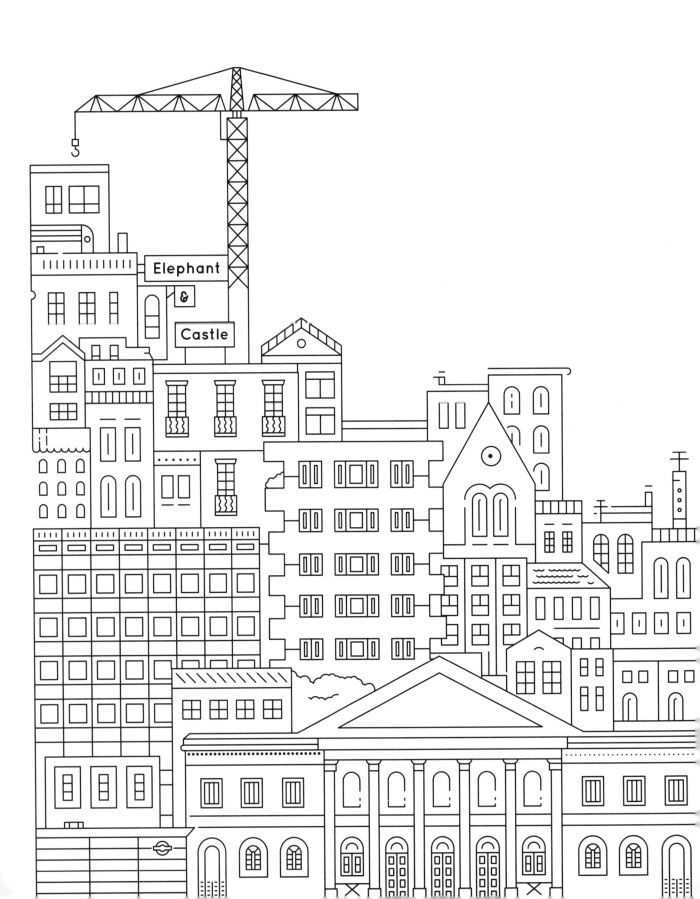

How did 'Elephant & Castle' get its unique name? Some say that the 'castle' on the elephant's back was a misinterpretation of a 'howdah', a type of seating historically used to ride an elephant.

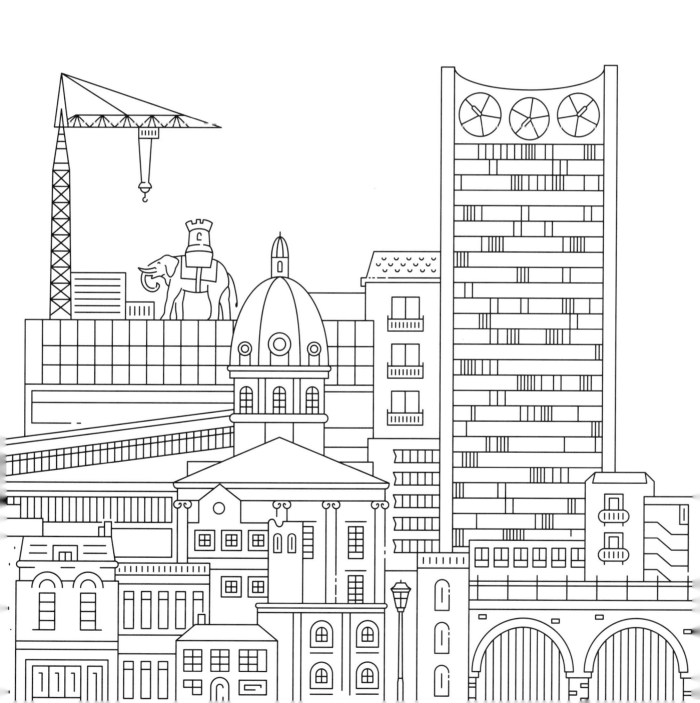

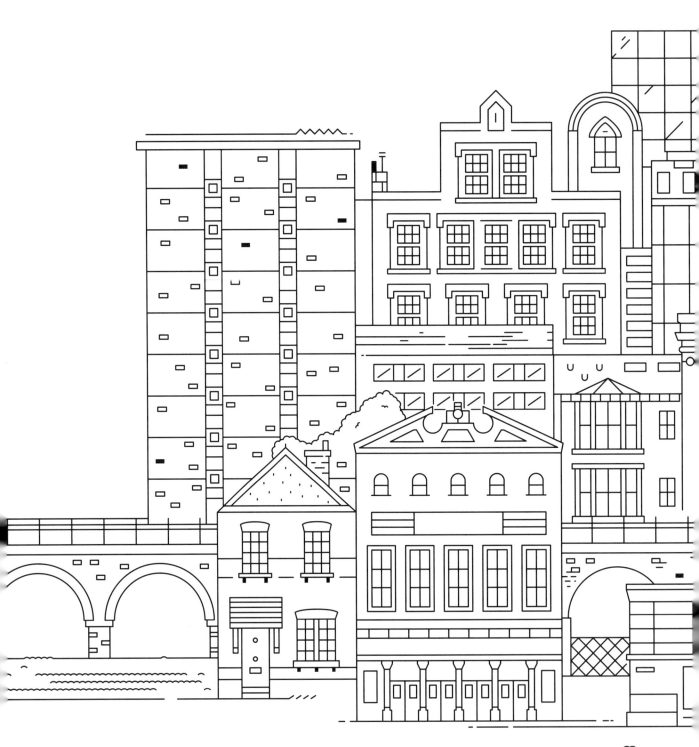

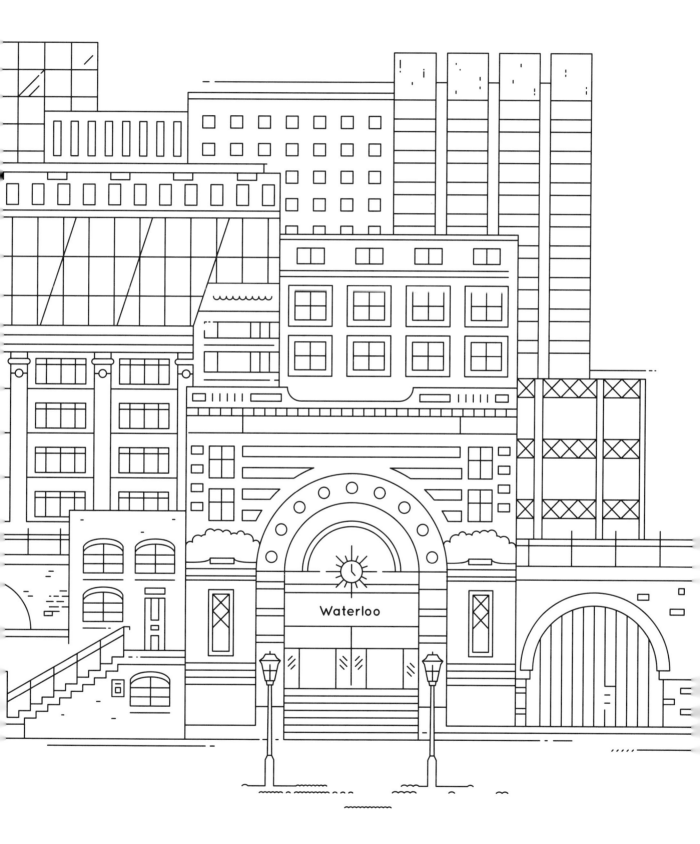

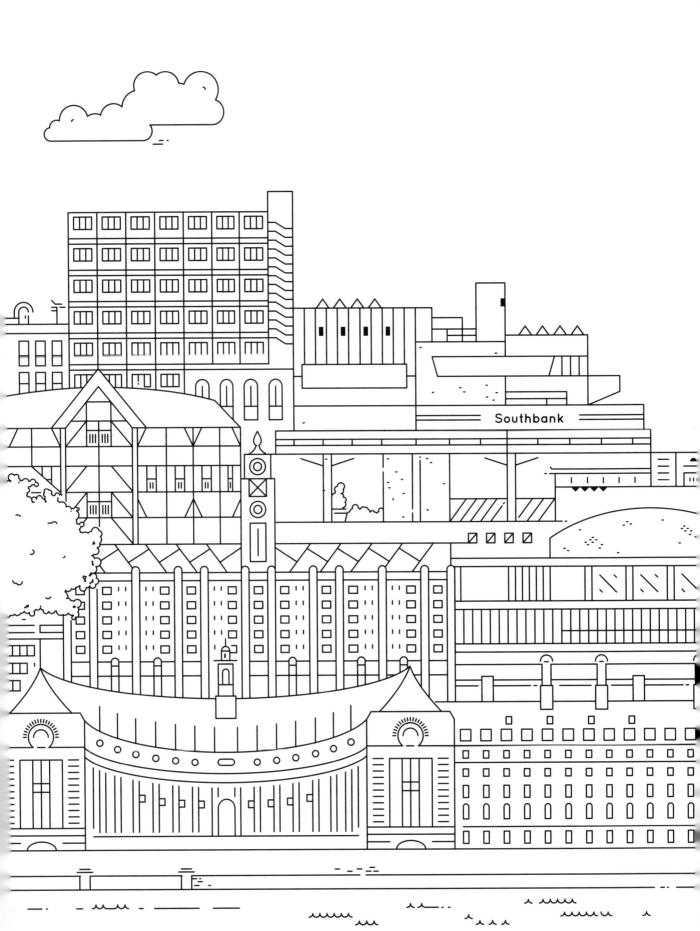

Each passenger capsule of the London Eye
represents one of London's boroughs.

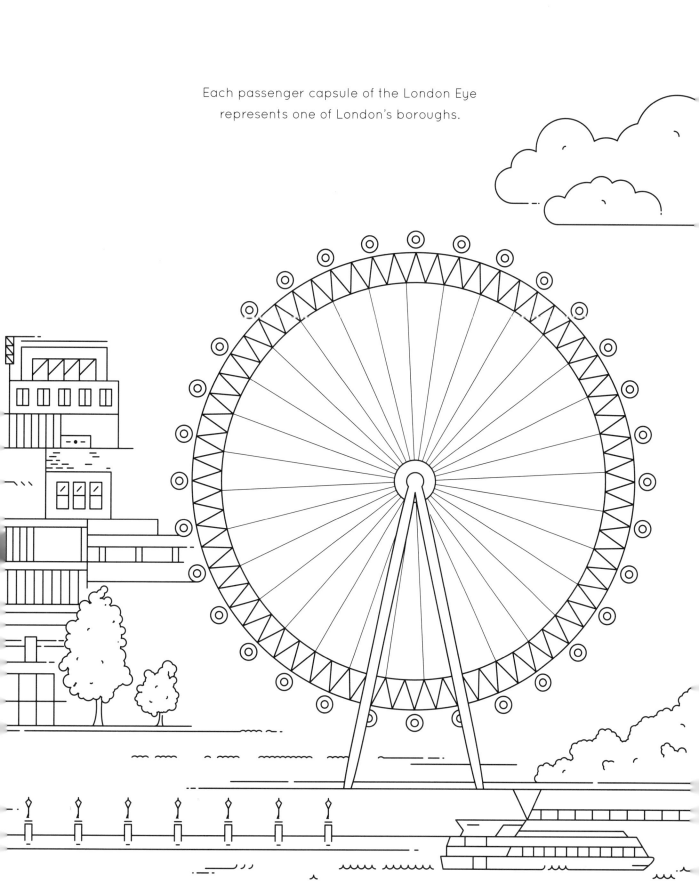

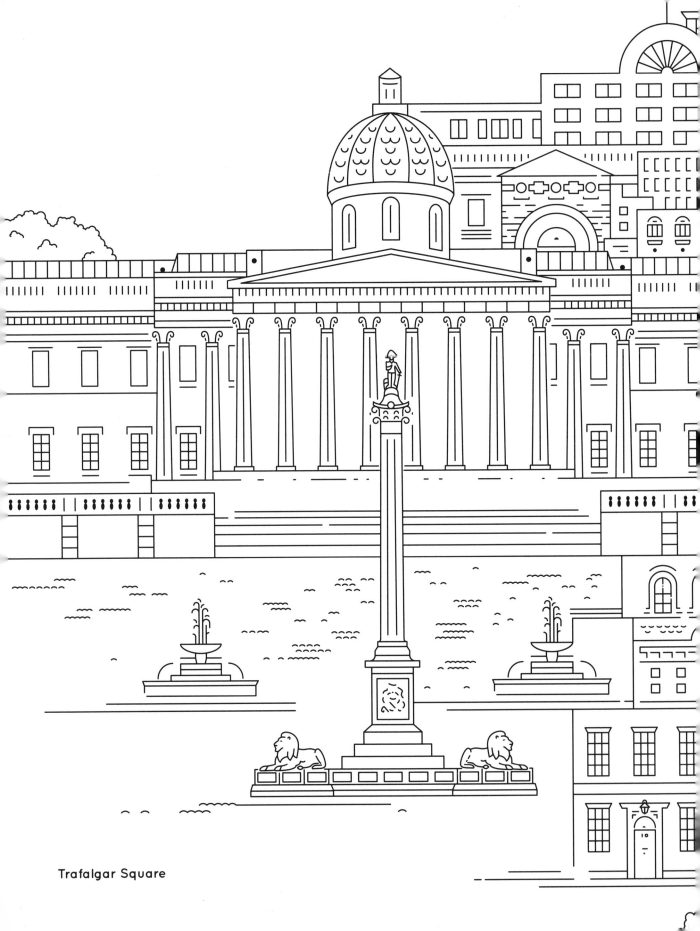

Trafalgar Square

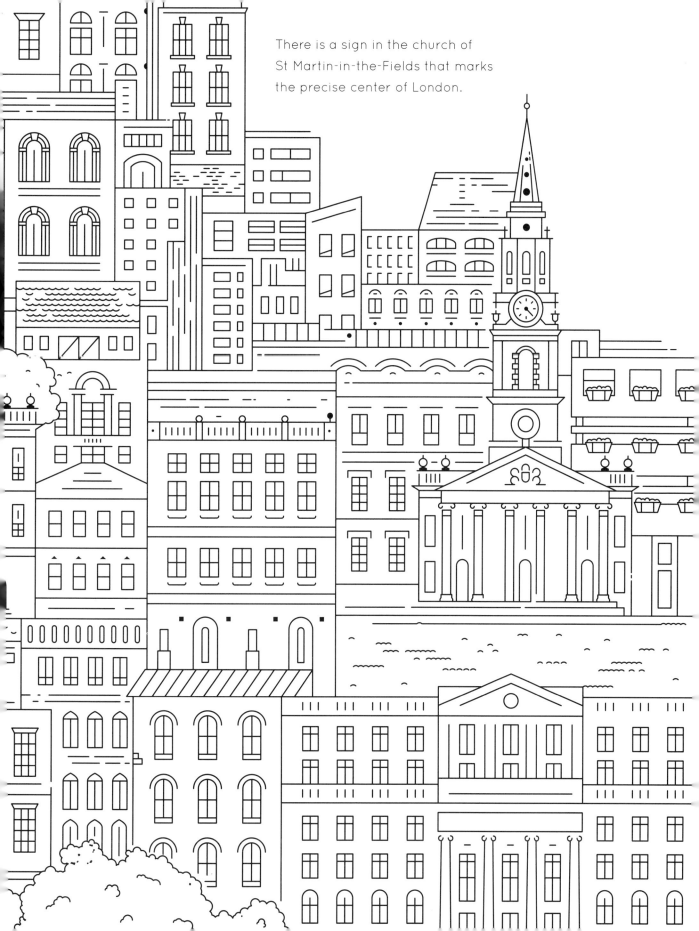

There is a sign in the church of
St Martin-in-the-Fields that marks
the precise center of London.

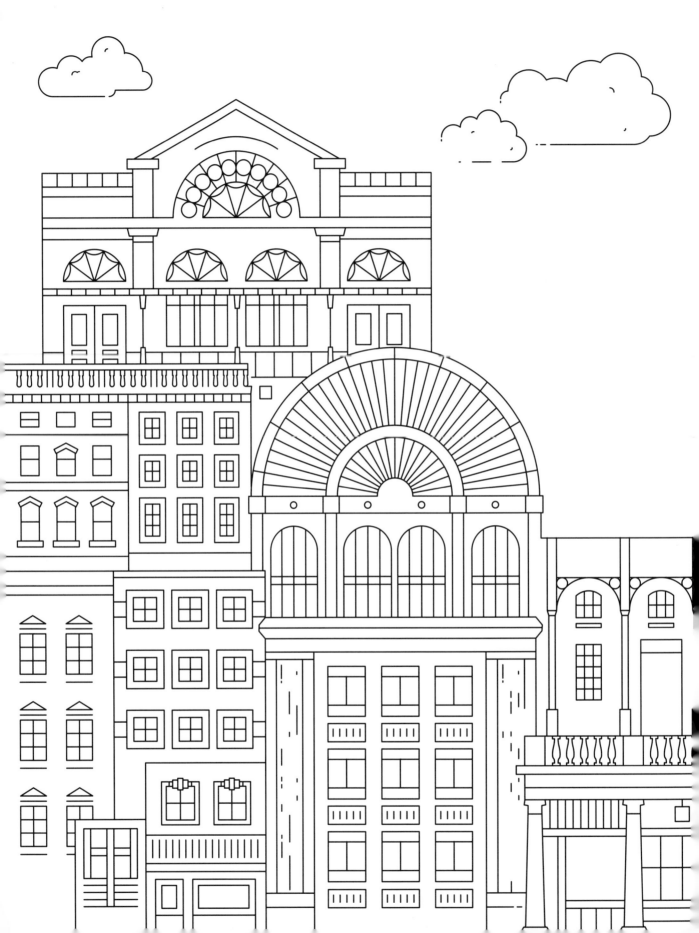

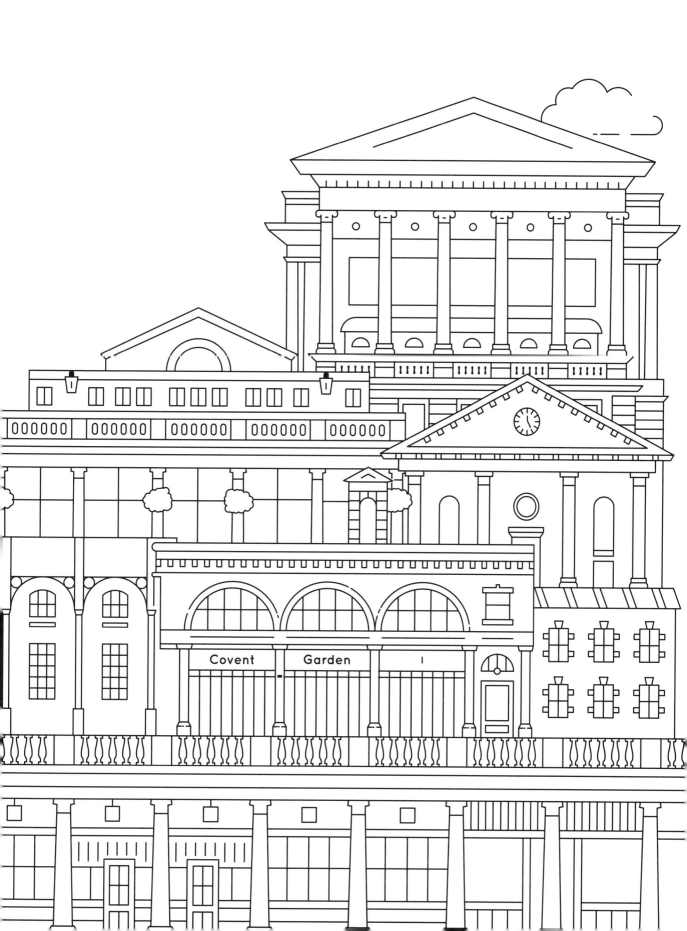

Covent Garden

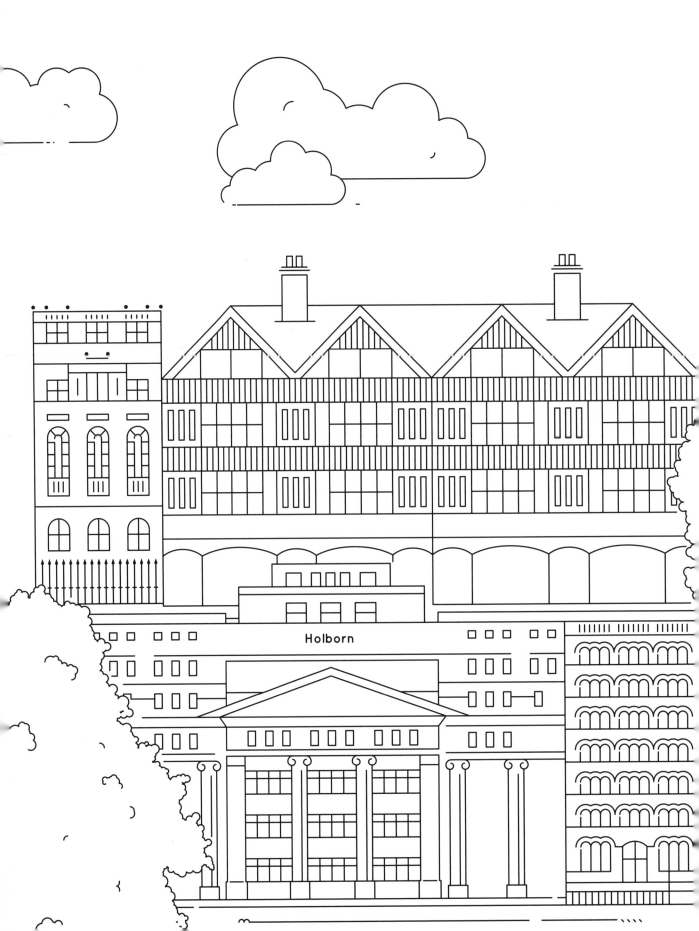

Holborn

The British Museum has a collection
of over 7 million artefacts.

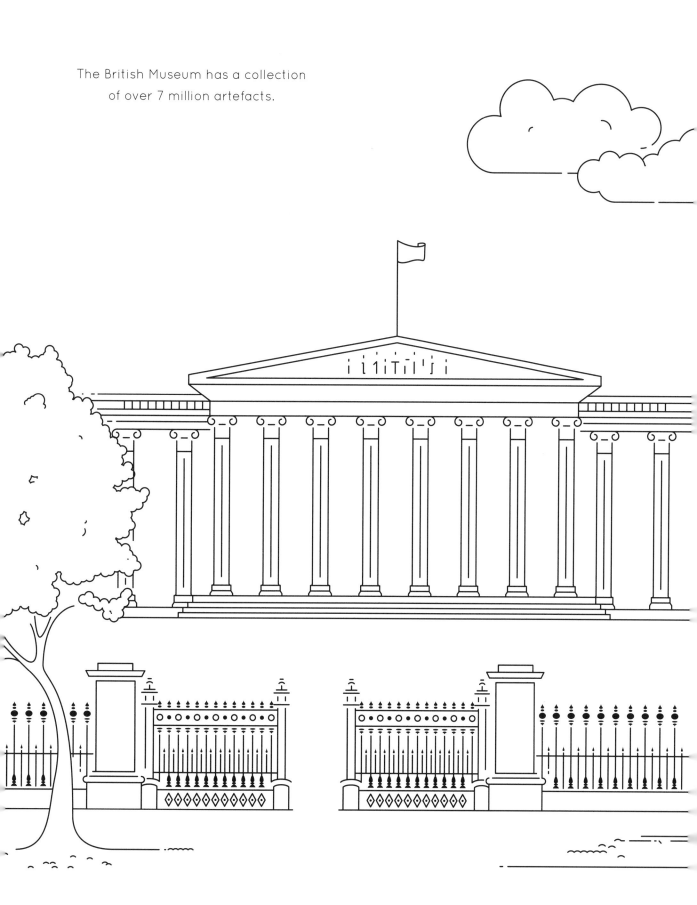

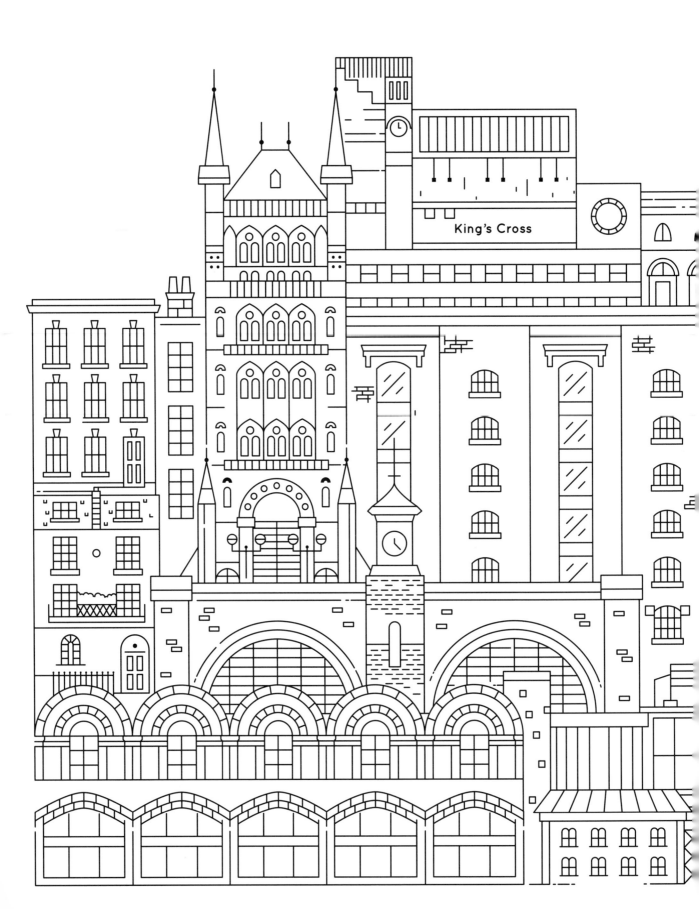

King's Cross

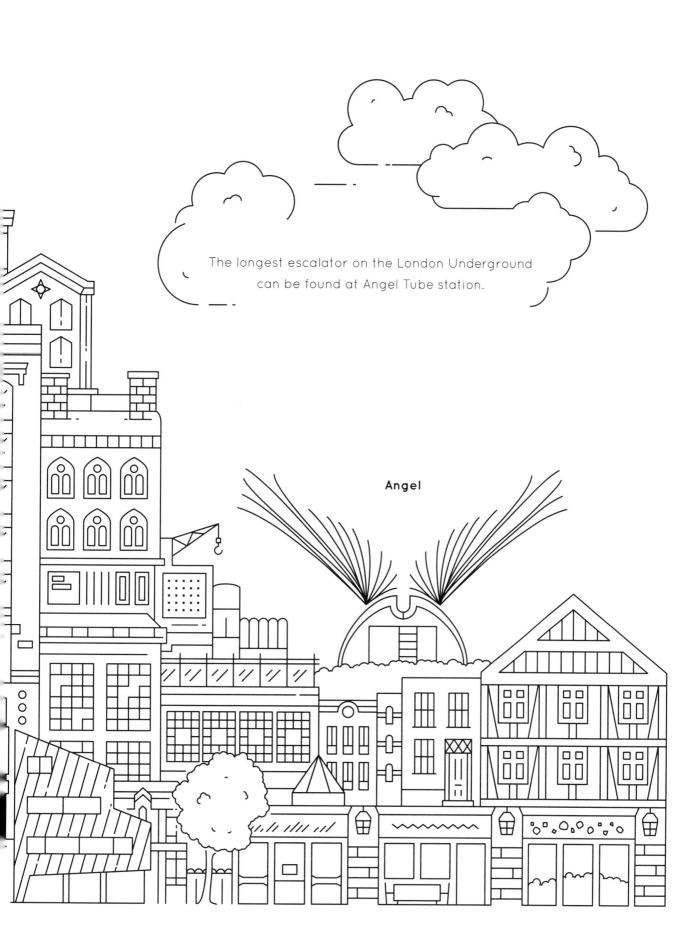

The longest escalator on the London Underground can be found at Angel Tube station.

Angel

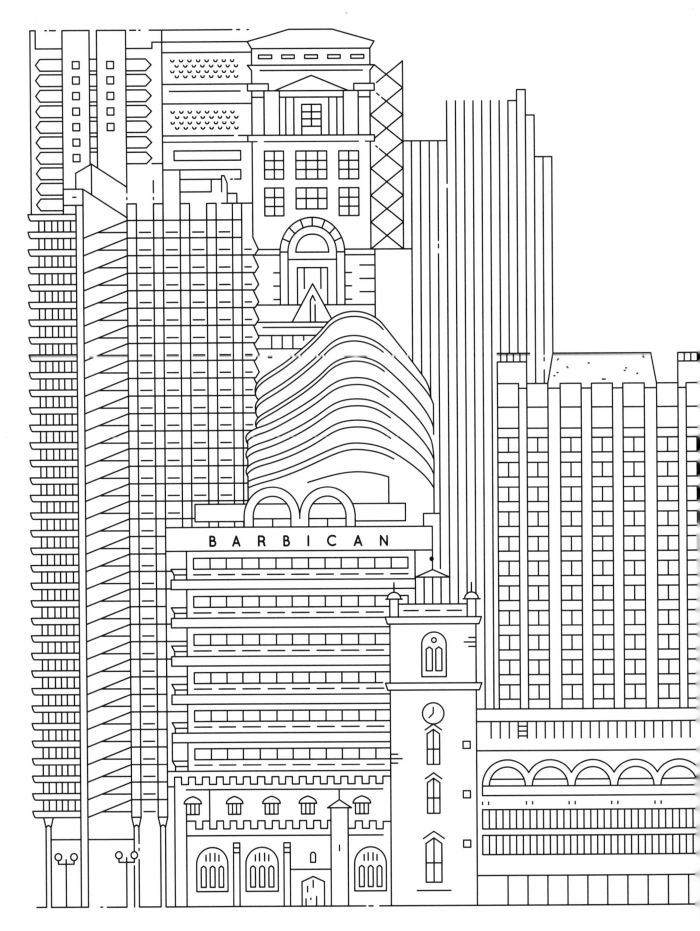

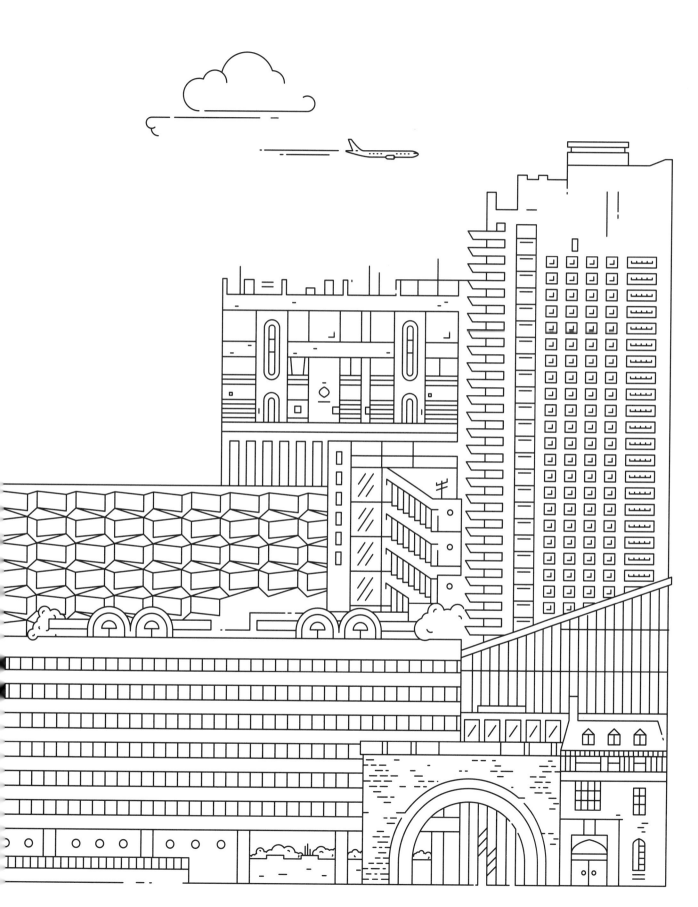

St Paul's Cathedral

There are dozens of rivers flowing
underneath London.

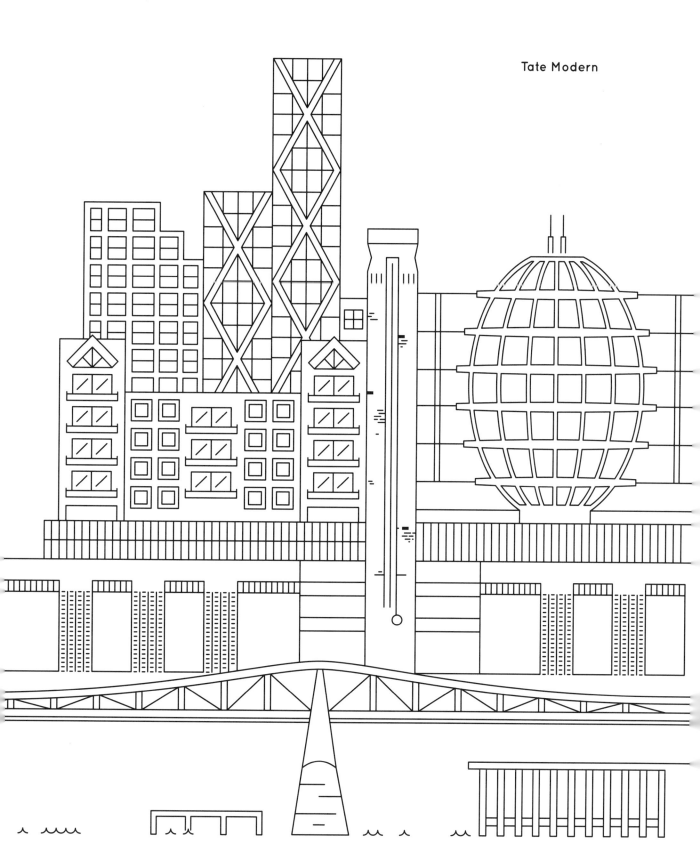

Tate Modern

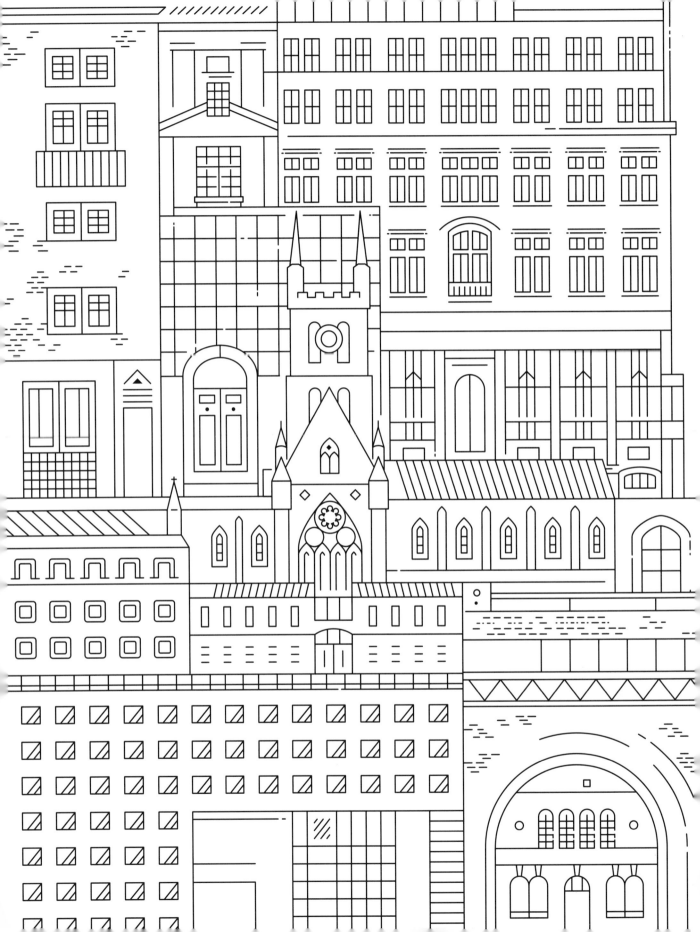

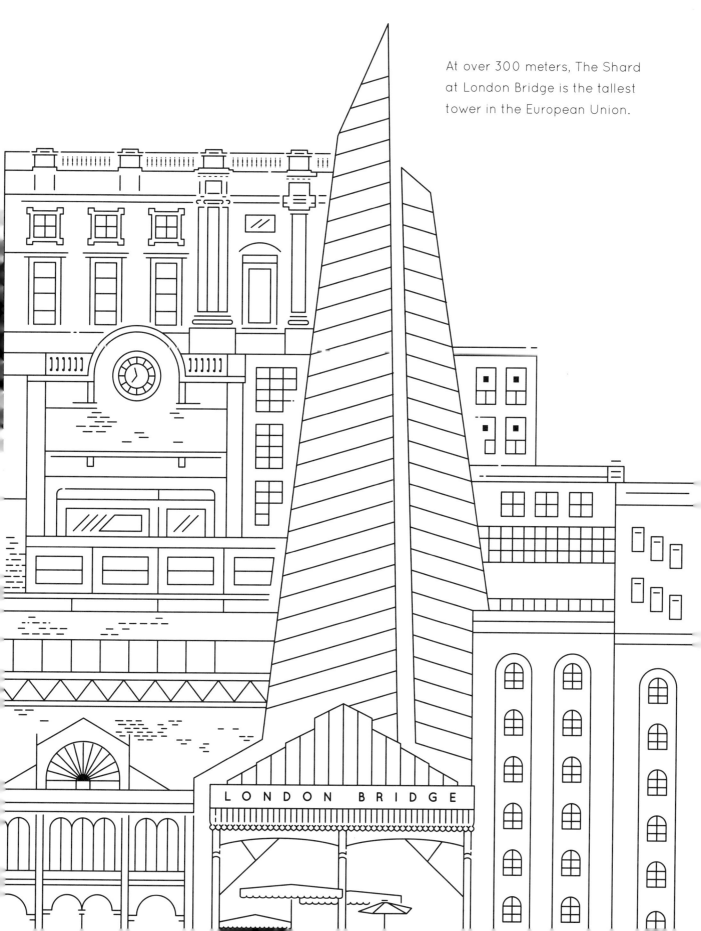

At over 300 meters, The Shard at London Bridge is the tallest tower in the European Union.

LONDON BRIDGE

The Great Fire of London in 1666
started in a bakery on Pudding Lane.
The Monument is a permanent
memorial of the fire, and was
opened in 1677.

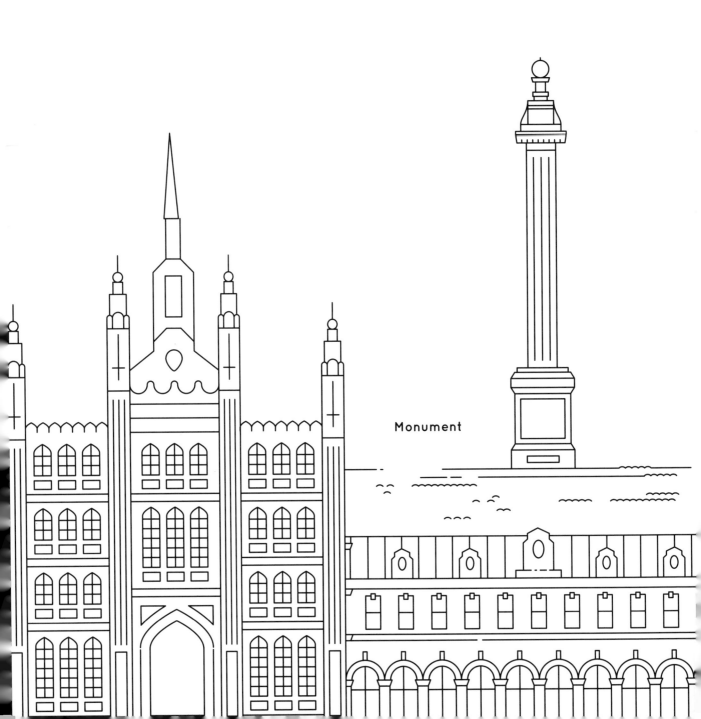

Monument

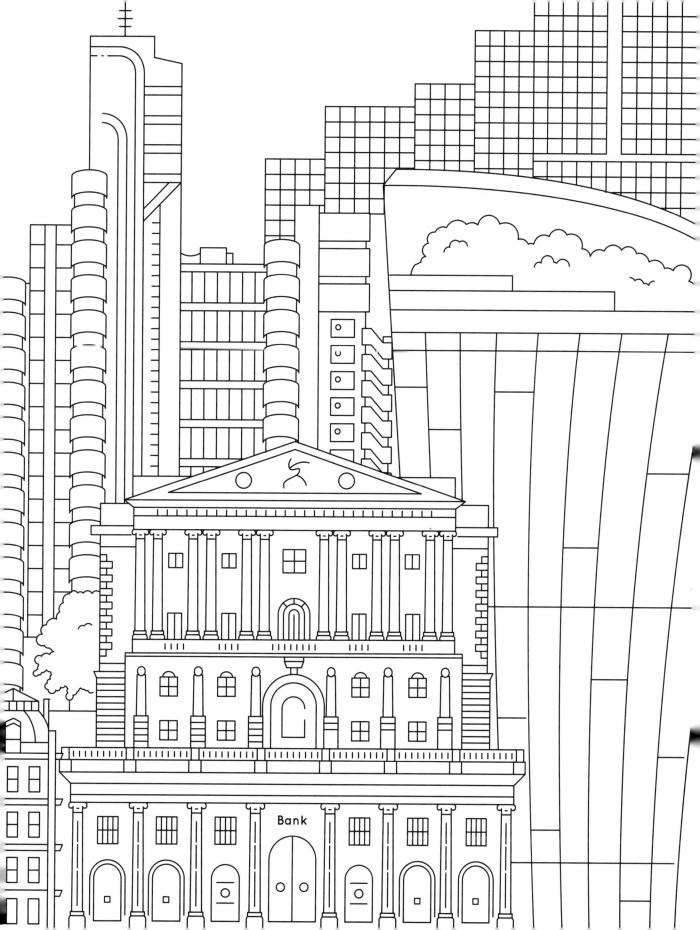

Bank

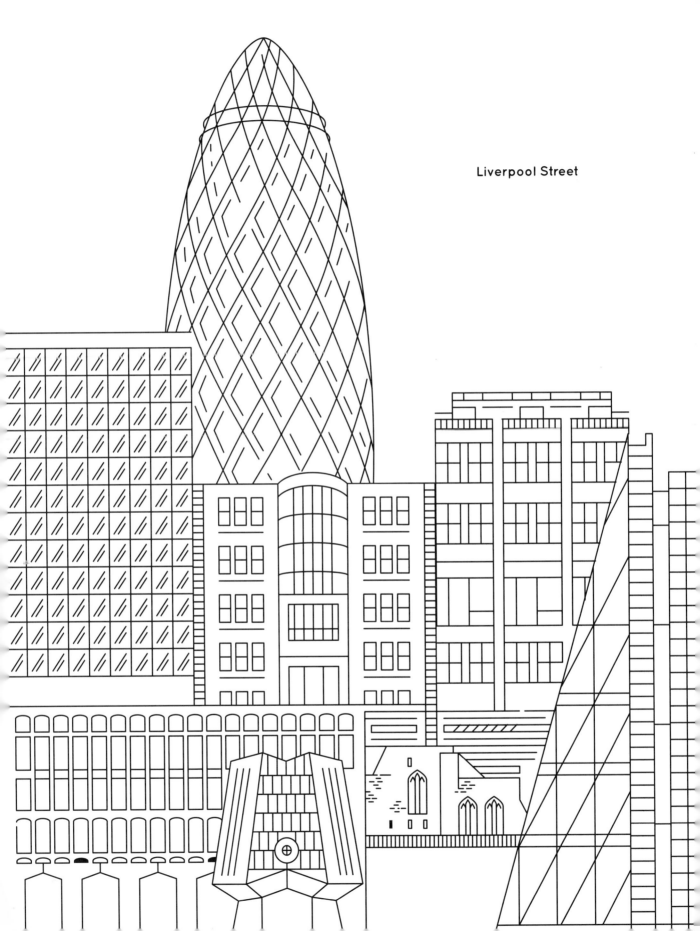

Liverpool Street

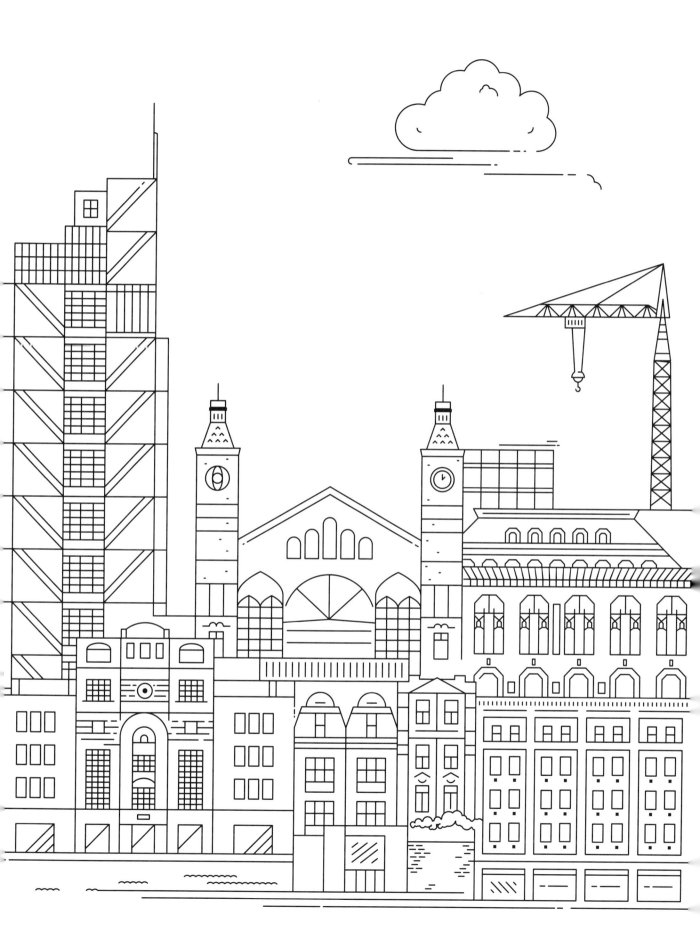

Shoreditch

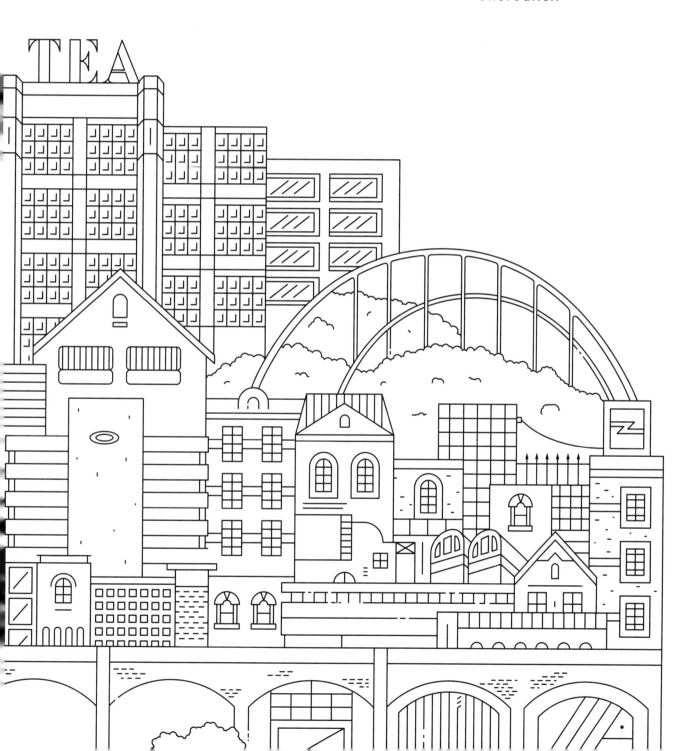

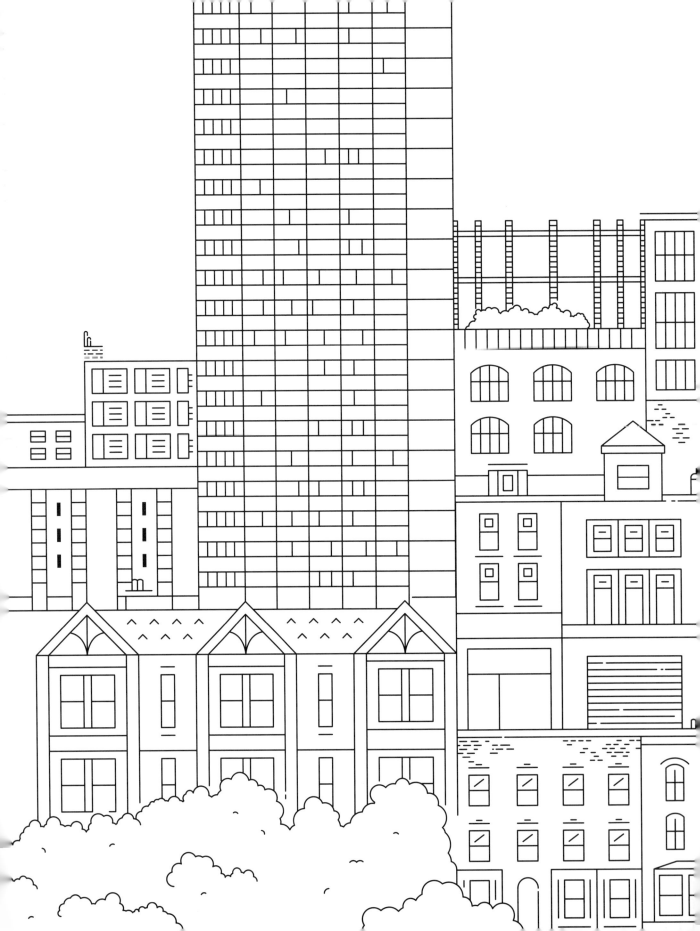

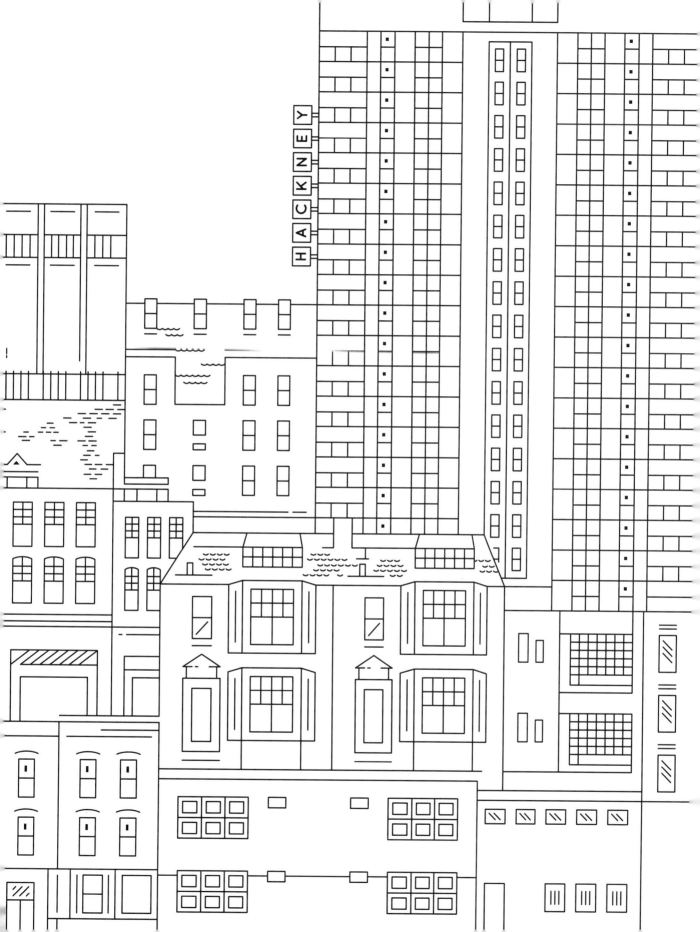

Brick Lane's famous Truman Brewery was said to be
the largest brewery in the world during the late 1800s.

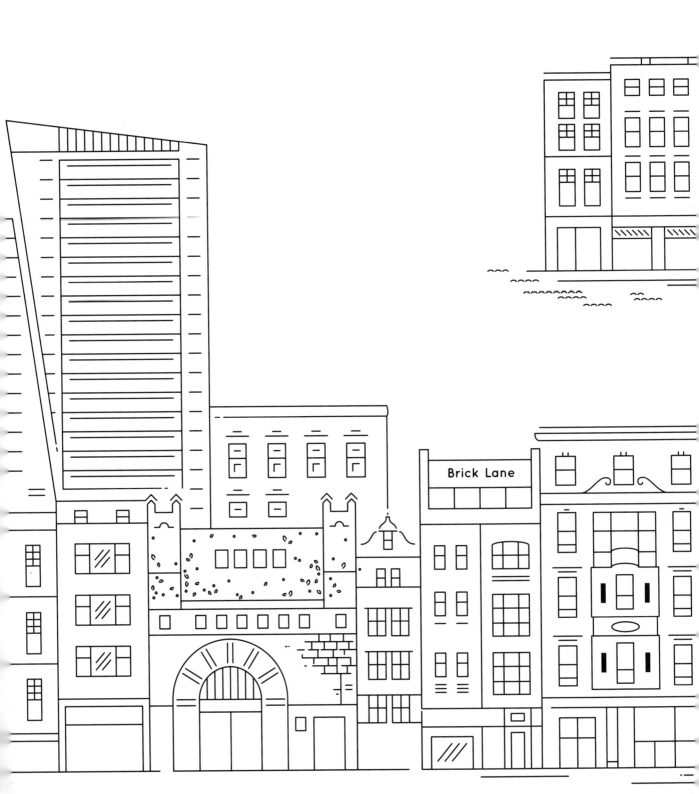

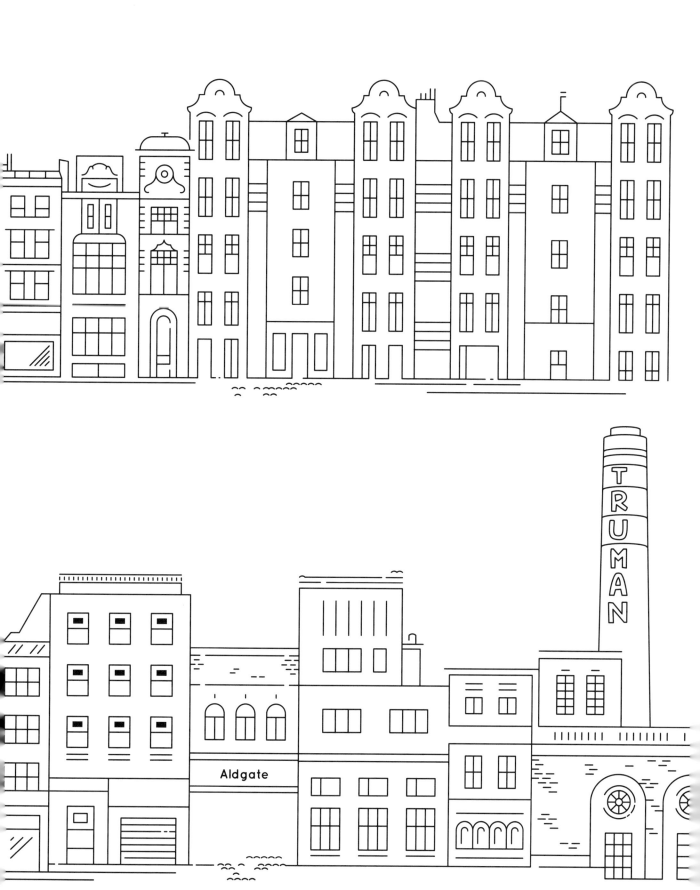

Aldgate

TRUMAN

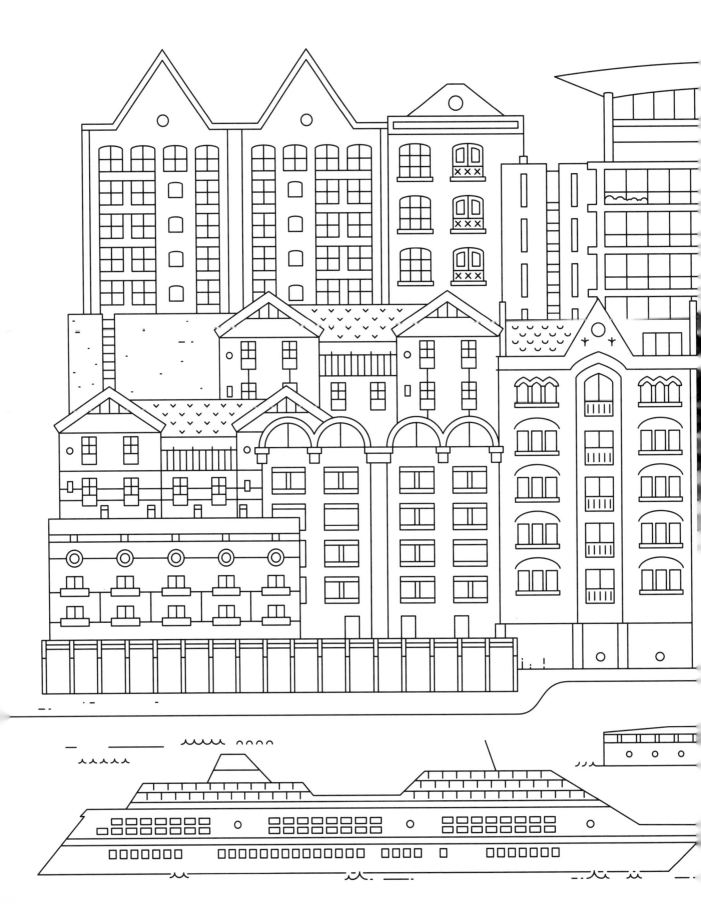

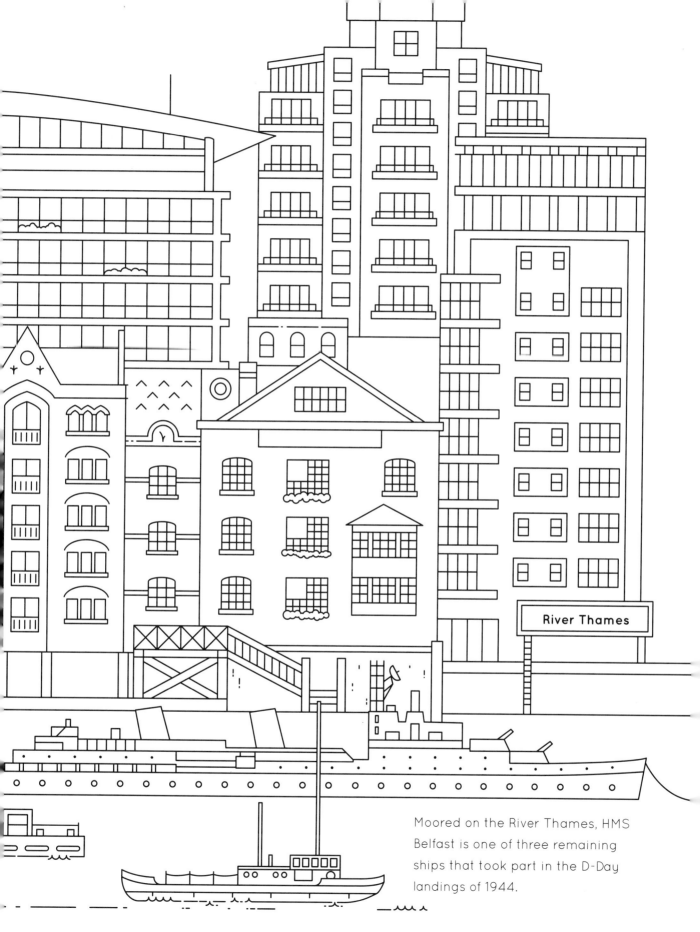

Moored on the River Thames, HMS Belfast is one of three remaining ships that took part in the D-Day landings of 1944.

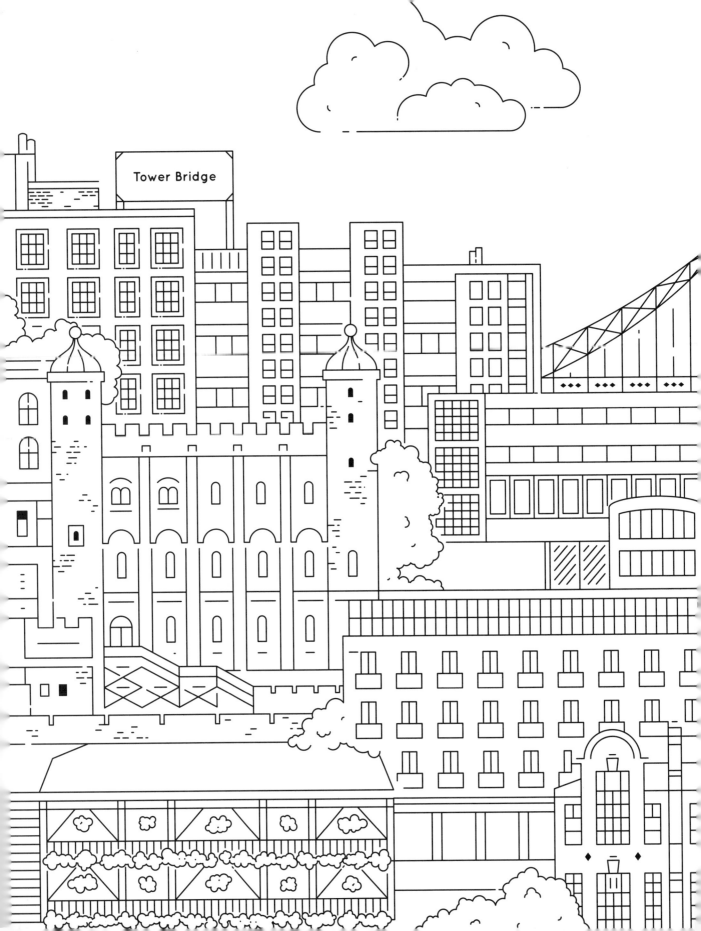

Tower Bridge

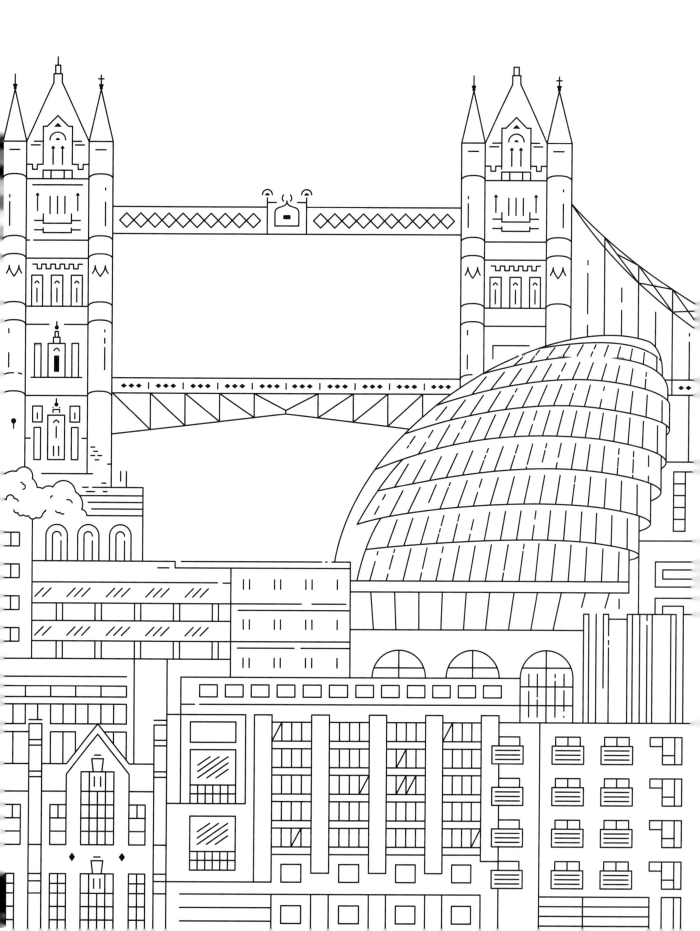

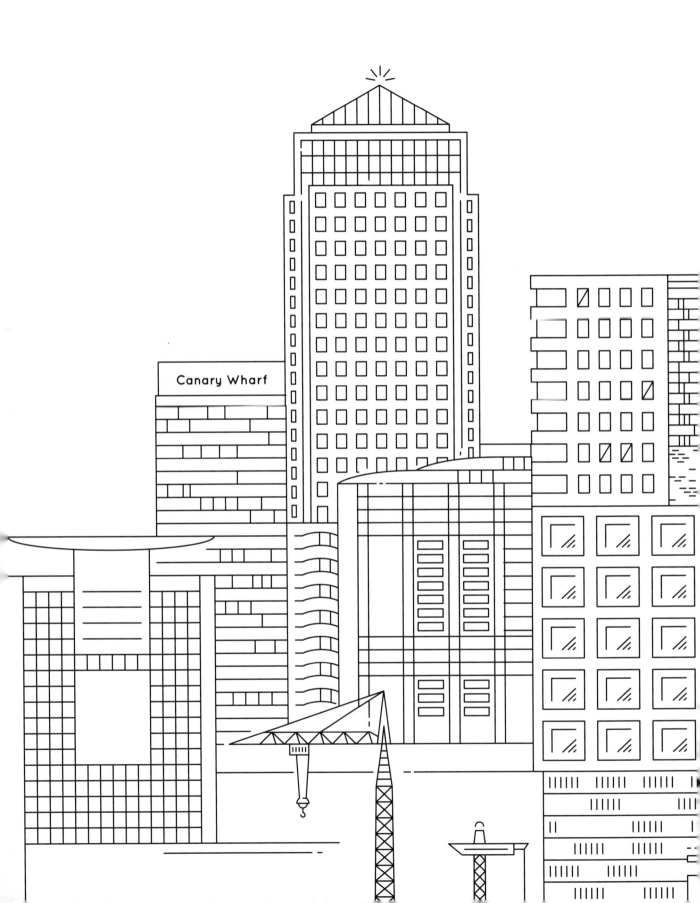

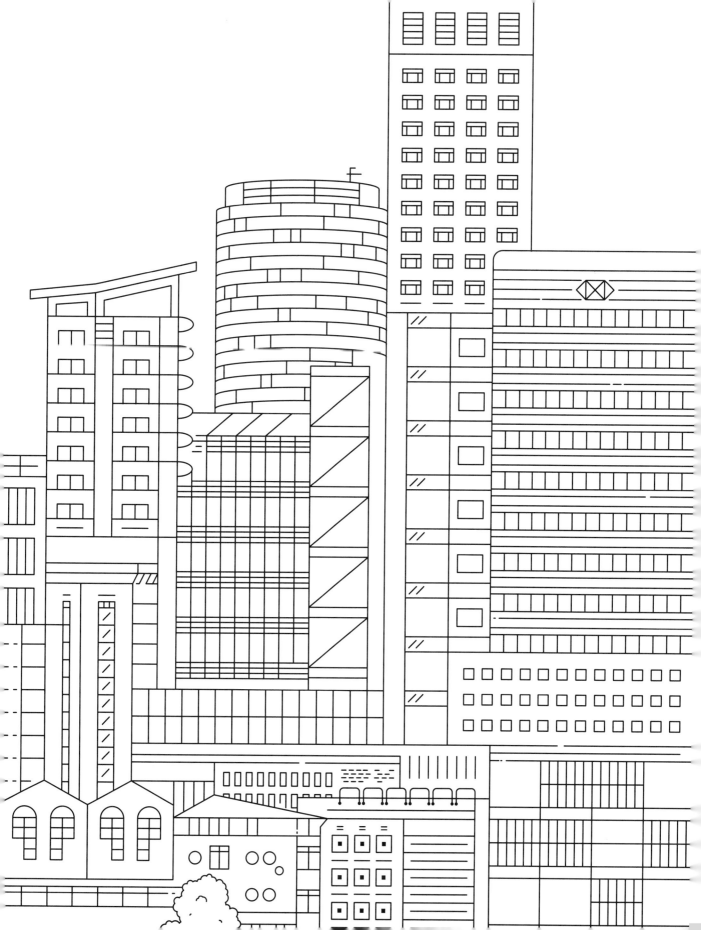

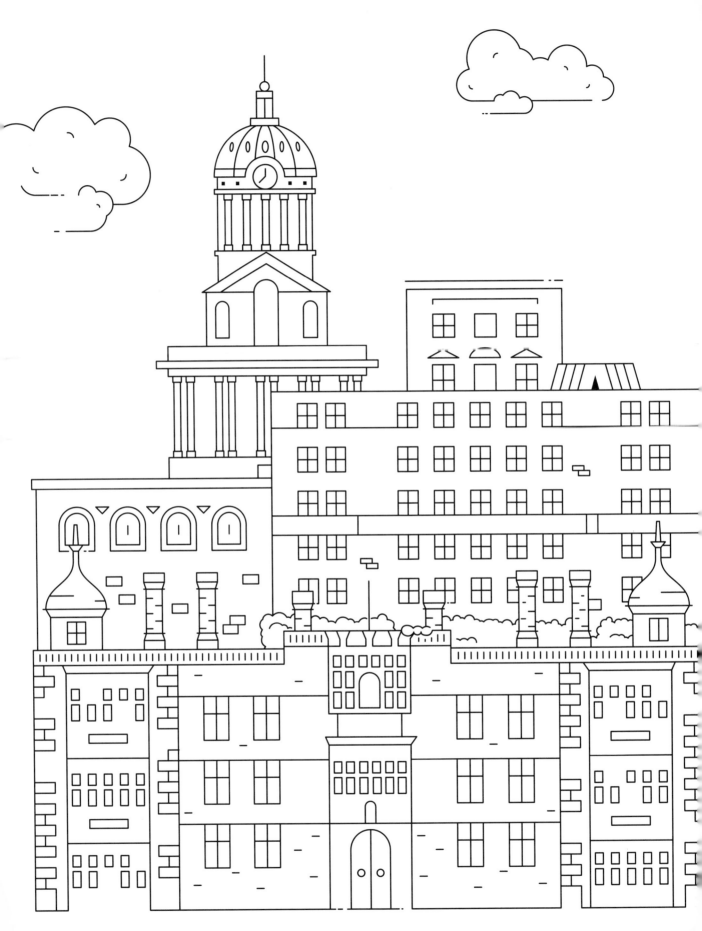

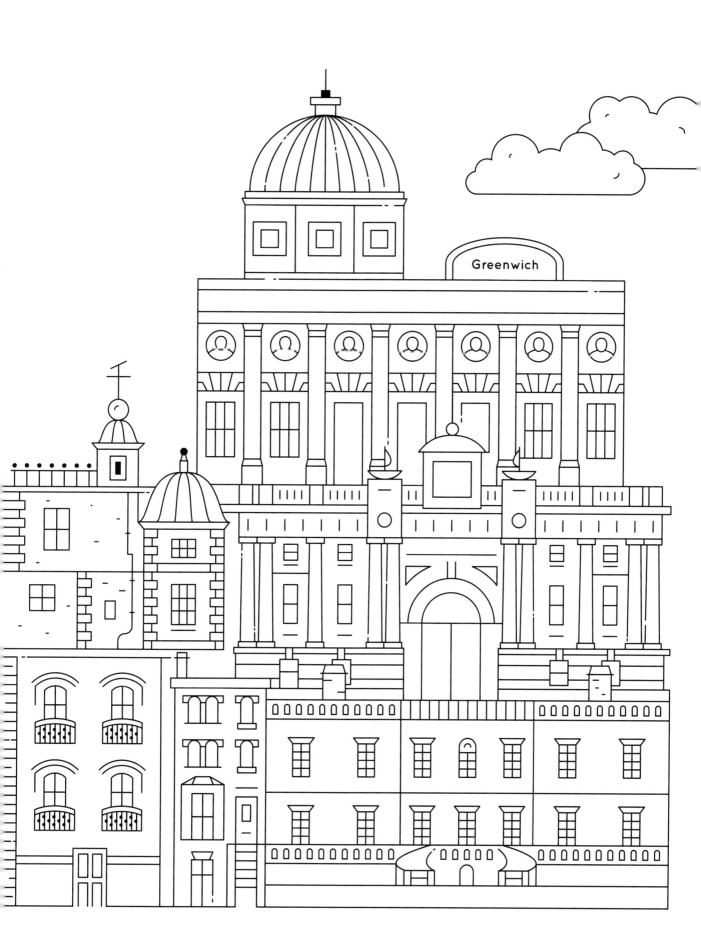

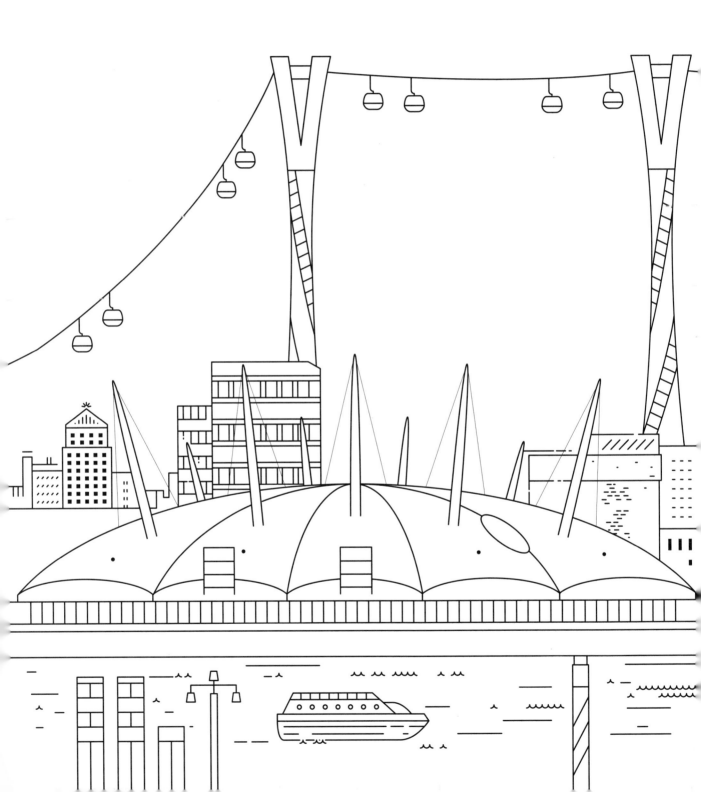

The Crystal exhibition center on Royal Victoria Dock
is one of the most sustainable buildings in the world.

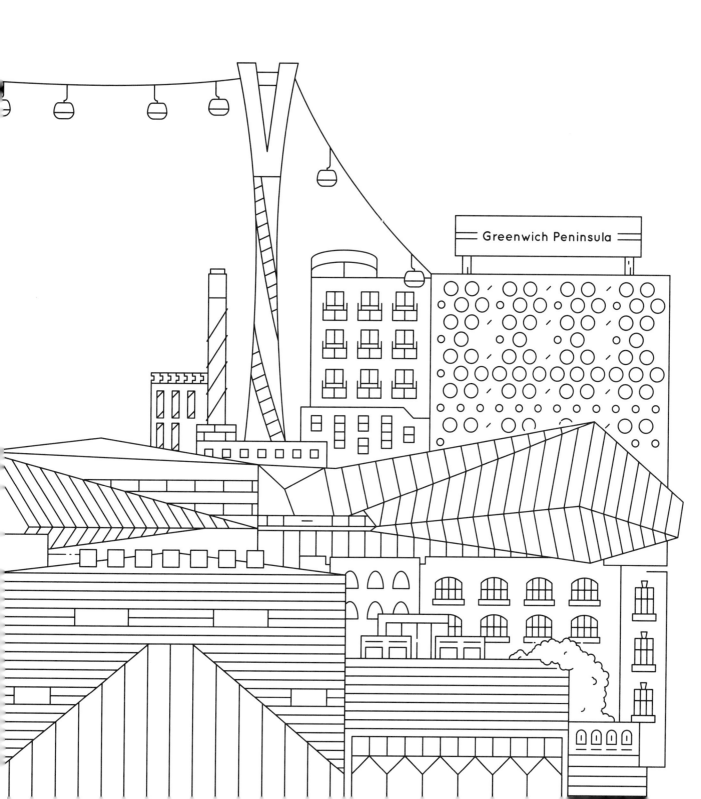

Greenwich Peninsula

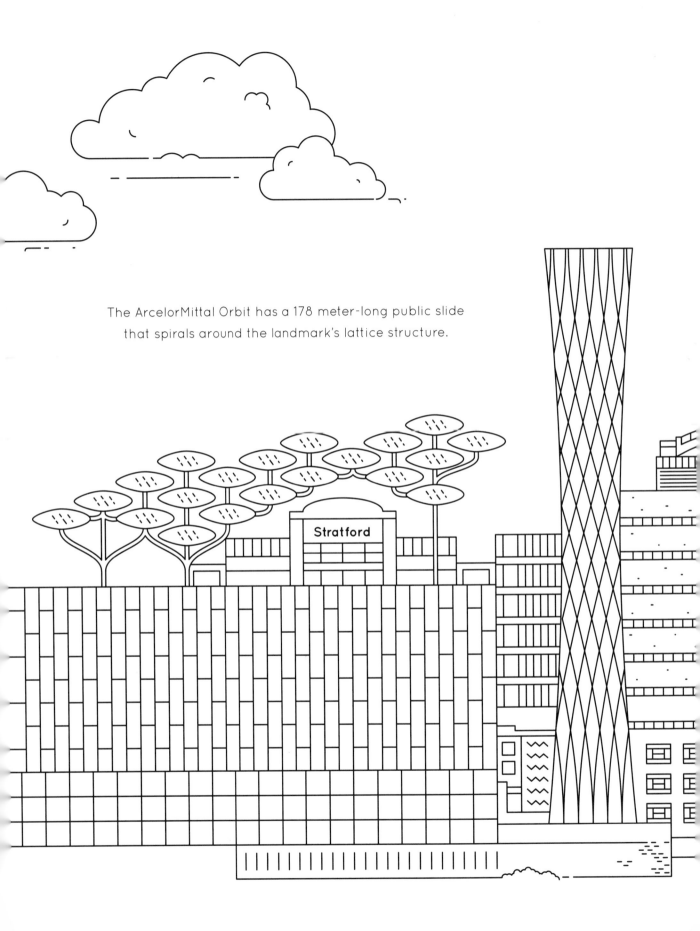

The ArcelorMittal Orbit has a 178 meter-long public slide that spirals around the landmark's lattice structure.

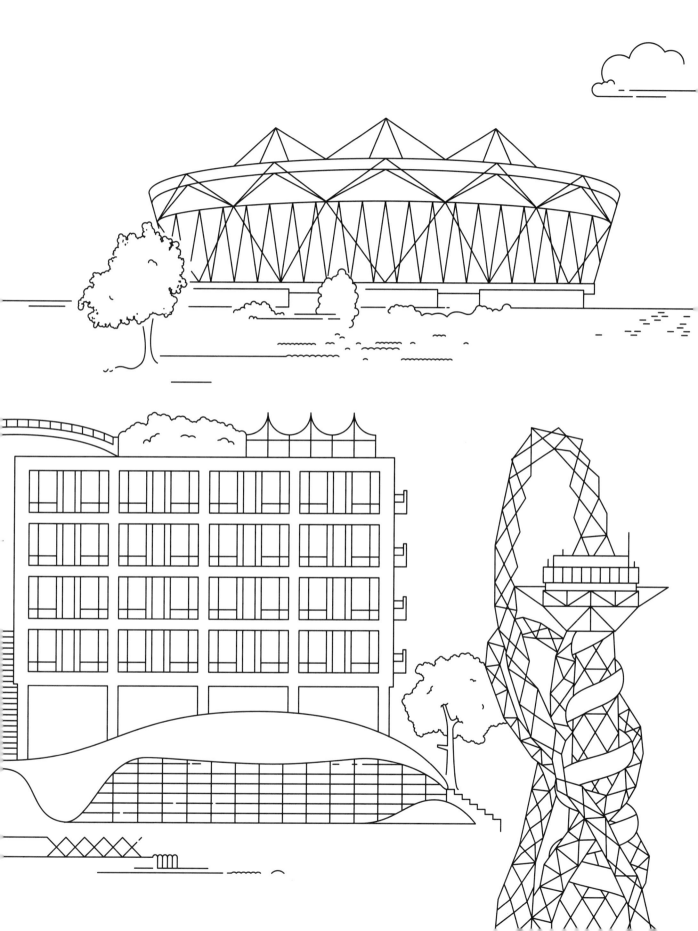

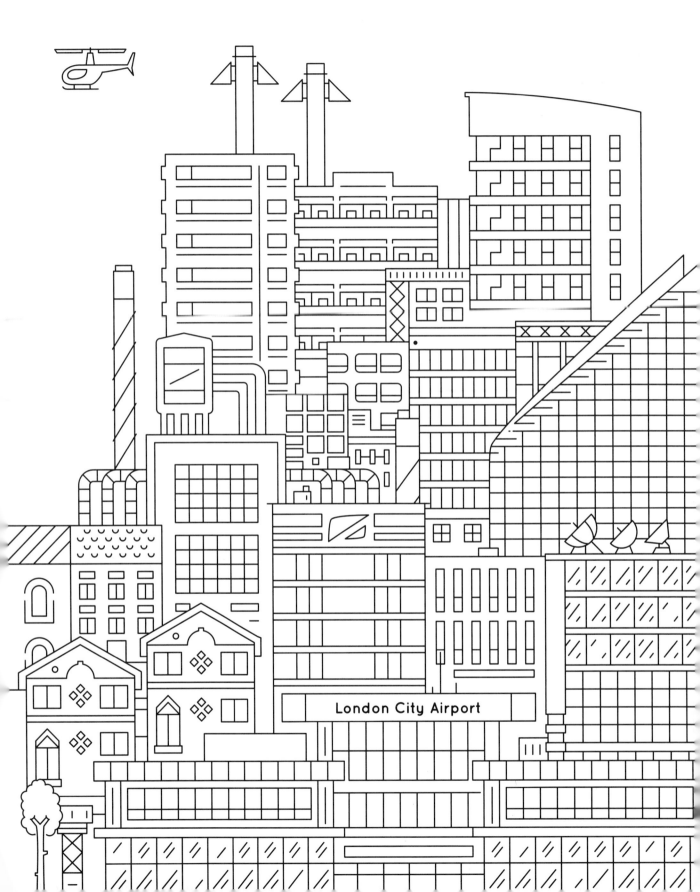

London City Airport

Aspiring to Draw the World

We like drawing places that draw people in, and spend our days and nights exploring interesting locations all over the world – sometimes by foot, sometimes by pen. There's so much charming complexity to life, and once we started drawing, we just couldn't stop!

After graduating together from art school in London, we always knew what a beautiful and diverse city it was. From Kensington to Kew Gardens, Hackney to Hampstead, England's capital really is a world in itself. It was a privilege to create this coloring tribute to London, and we would like to thank our publisher, Kate Pollard, for giving us such an exciting opportunity.

This book took inspiration from an ongoing project of ours called *The City Works*. If you'd like to learn more about us and see more of our designs, you can visit us at www.thecity.works or follow us @thecityworks on all social media.

We hope that you enjoyed getting *Lost in London*, and we look forward to taking you on other urban adventures in the future.

Sylvia & Rowan

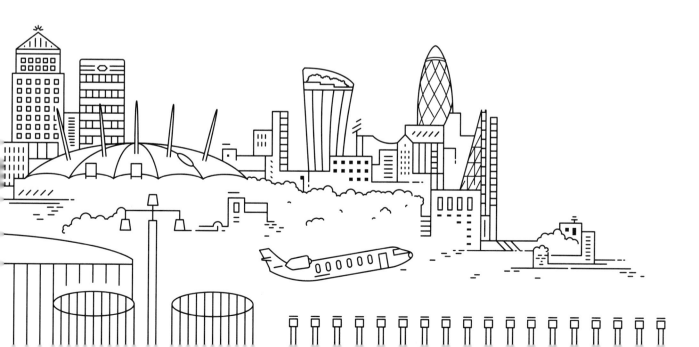

Lost in London by Sylvia Moritz and Rowan Ottesen

First published in 2016 by Hardie Grant Books

Hardie Grant Books (UK)
5th & 6th Floors
52-54 Southwark Street
London SE1 1UN
hardiegrant.co.uk

Hardie Grant Books (Australia)
Ground Floor, Building 1
658 Church Street
Melbourne, VIC 3121
hardiegrant.com.au

British Library Cataloguing-in-Publication Data. A catalogue record
for this book is available from the British Library.

ISBN: 978-1-78488-066-8

Publisher: Kate Pollard
Senior Editor: Kajal Mistry
Editorial Assistant: Hannah Roberts
Art Direction: Sylvia Moritz and Rowan Ottesen
Colour Reproduction by p2d

Printed and bound in China by 1010

10 9 8 7 6 5 4 3 2 1

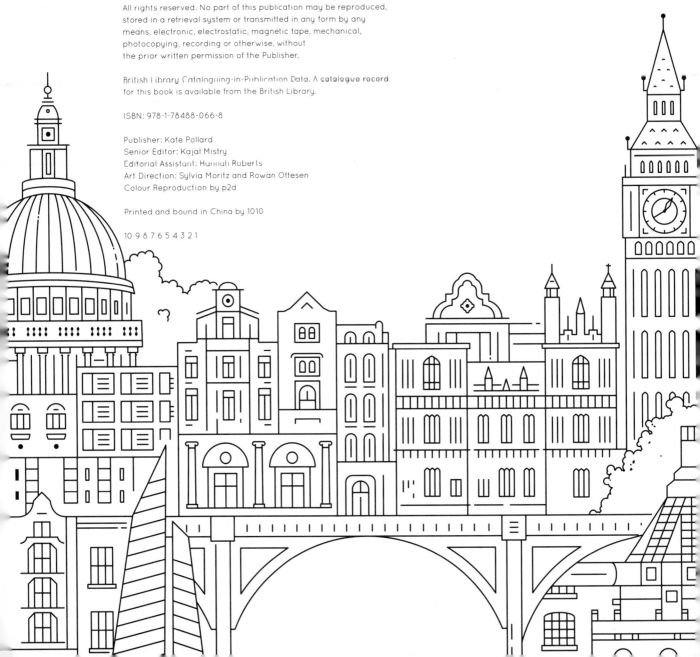

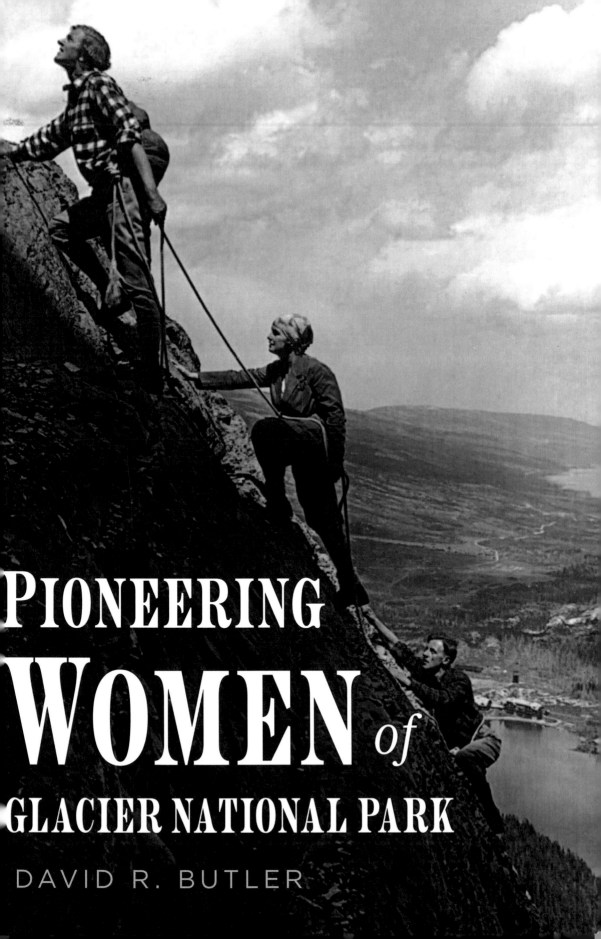

PIONEERING
WOMEN *of*
GLACIER NATIONAL PARK

DAVID R. BUTLER